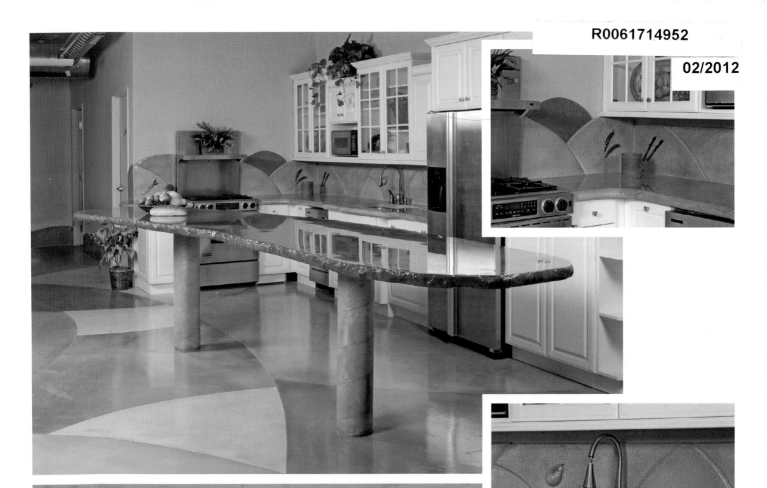

Casting Concrete Countertops

Tina Skinner

Doug Bannister

4880 Lower Valley Road, Atglen, PA 19310

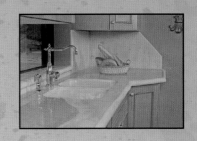

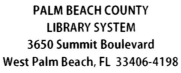

Acknowledgements

Special thanks to:

Project Coordinator: Coyne Edmison
Project editor: Dinah Roseberry
Photography: Doug Congdon-Martin
Translator: Jennifer McKay-Simons
Stamp Store craftsmen: Grant Barnes, Patty Cason, Salome Charqueno, Josh Cunningham, Timothy Frazier, and Rick White.

Published by Schiffer Publishing Ltd.
4880 Lower Valley Road
Atglen, PA 19310
Phone: (610) 593-1777; Fax: (610) 593-2002
E-mail: Info@schifferbooks.com

For the largest selection of fine reference books on this and related subjects, please visit our web site at
www.schifferbooks.com
We are always looking for people to write books on new and related subjects. If you have an idea for a book please contact us at the above address.

This book may be purchased from the publisher.
Include $3.95 for shipping.
Please try your bookstore first.
You may write for a free catalog.

In Europe, Schiffer books are distributed by
Bushwood Books
6 Marksbury Ave.
Kew Gardens
Surrey TW9 4JF England
Phone: 44 (0) 20 8392-8585; Fax: 44 (0) 20 8392-9876
E-mail: info@bushwoodbooks.co.uk
Website: www.bushwoodbooks.co.uk
Free postage in the U.K., Europe; air mail at cost.

Designed by Ro Shillingford
Cover Design by Bruce M. Waters
Type set in Americana BT/NewBskvll BT

ISBN: 978-0-7643-2865-7
Printed in China

Contents

Indice

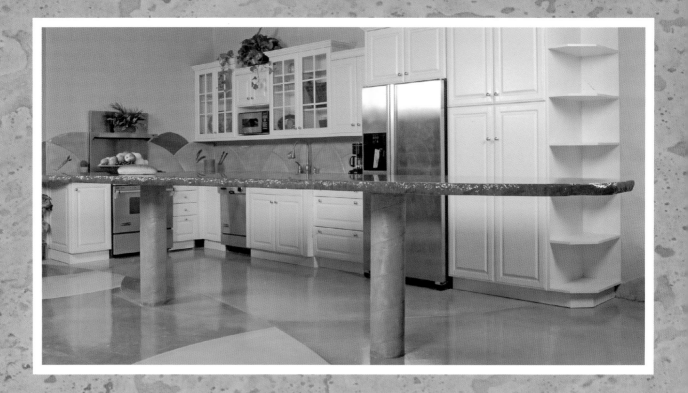

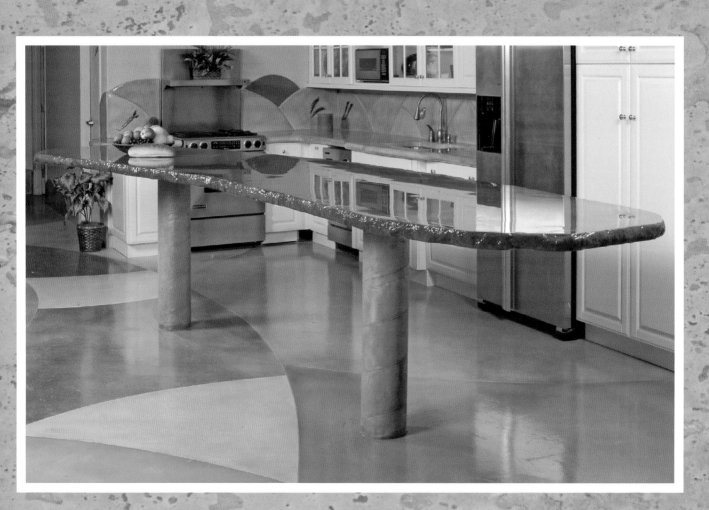

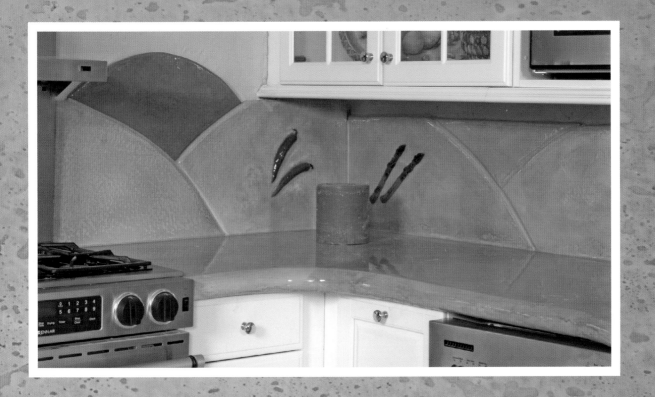
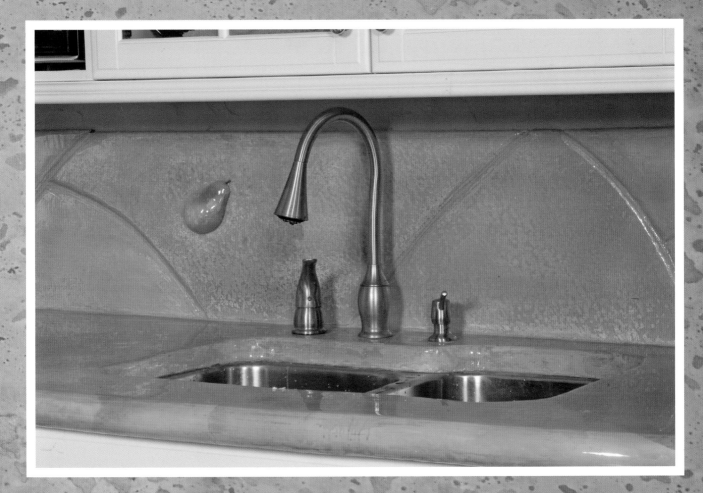

Part I
Introduction

Doug Bannister is considered one of the leading experts in the decorative concrete industry. He was selected as one the 10 Most Influential Persons in the concrete industry in 2007. He was a former Director the Decorative Concrete Council (DCC) and member of the American Society of Concrete Contractors (ASCC). He is an active participant and presenter at World of Concrete events. Founded The Stamp Store in 1995, he was the first to offer decorative concrete products online. The Stamp Store was the first company to offer training with the focus on sharing important information rather than product sales.

Bannister continues to offer training "Deminars" twice a month at the Oklahoma City showroom. Contractors and designers take introductory and advanced classes in decorative concrete. Many come because they are interested in starting a business in decorative concrete.

For years, Doug Bannister found himself answering design and build questions about concrete countertops that resist cracking and curling. So he decided to make it easy by packaging his own custom blend, perfected through years of trial and error. The result is enCOUNTER, a factory blended professional-grade countertop mix that requires less water, yet is sweeter than the best mix you ever ran a float and trowel over.

The enCOUNTER professional concrete countertop system is packaged in 50 lb. easy-to-handle bags for ultimate convenience and it reaches over 8,500 psi in 28 days with water alone. enCOUNTER is a crushed limestone structural concrete mix that successfully cantilevers where sand mixes fail and requires no joints like other mixes. Put simply, enCOUNTER is possibly the best cast-in-place mix on the planet, and it works wonders for pre-cast concrete applications, too! The product is available in gray or white and readily accepts all concrete coloring methods including concrete color stains and enCOLOR liquid pigment, a family of 15 colors with a broad tonal range. The mix offers less guesswork, greater convenience, and superior strength and performance.

Among the skills the Stamp Store teaches are techniques for stamped overlay concrete for existing concrete, acid and water-based staining, scoring, stencils, countertops, and guidelines on how to start a decorative concrete business. Advanced students hone their skills in stamped concrete, polymer overlays for existing concrete, acid and water-based staining, countertops, and how to start and/or improve their decorative concrete business.

Company founder Doug Bannister has been involved in decorative concrete treatments work since 1980. He worked first as a decorative concrete contractor and continued to contract jobs while innovating new concrete products.

Together with Stan Pace, Bannister helped pioneer the FossilCrete Vertical Concrete Texturing System, which offers a vertical concrete system and 3D impression tools that help contractors and do-it-yourself craftsman to create art forms that mimic the natural world, like fossils, animal tracks, plants, and sea life. In 2006, FossilCrete was honored with the prestigious Expert's Choice Most Innovative Products Award in the decorative concrete category, at the World of Concrete Show in Las Vegas. Today, FossilCrete products are distributed nationwide and of course by the Stamp Store along with the other Bannister's growing line of decorative concrete products.

The Stamp Store offers a complete line of decorative concrete materials backed by professional and dedicated technical support. Products include concrete coloring agents, concrete sealers, concrete texturing tools, finishing tools, and chemical admixtures. Decorative concrete equipment includes vibratory screeds, specialty saws, and tools. This includes decorative concrete interior floor systems with acid stains, top coats, or concrete maintenance products, exterior stamped concrete materials, concrete countertop forms and sink molds, concrete mix and sealers as well as materials for vertical concrete applications like an exterior waterfall or interior fireplace, surround stone wall, or shower.

Parte I
Introduccion

Doug Bannister es uno do los primeros expertos en la industria del concreto decorativo. El estaba eligido como uno de las personas mas influyente en la industria del concreto en 2007.

El fue el Director pasado del consejo del concreto decorative (DCC) y un miembro de la sociedad americano de contratista de concreto (ASCC). El is un participante activo y un instructor a los eventos del mundo del concreto. El is fundador de La Tienda de Estampas en 1995 y fue el primero a vender los productos decoratives en linea. La Tienda de Estampas fue la primera impresa a ofrecer instruccion para compartir informacion mas de vender productos.

Bannister continue ofrecer, dos veces cada mes, las instruccions que se llama "Deminars" a la sala de exposicion en la ciudad de Oklahoma. Las contratistas y los disenadores toman clases de introduccion y las mas avanzadas en concreto decorativo. Muchas personas toman clases porque quieren empezar un negocio de concreto decorativo.

Hace anos que Doug Bannister responde a preguntas sobre el designo y constructo del tableros de concreto que no fracciona y acurruca. El tenia la buena idea a producir su propio combinacion perfectado despues de anos de metodo de tanteos. El resultado es enCOUNTER, una mexcla del tablero, combina en fabrica, qu es de calidad profesional. La mexcla necesita menos agua, aun es mejor que cualquier mexcla que sea conocer.

El sistema de enCOUNTER concreto profesional par el tablero esta empaquetado en las bolsas de 50 libras, que se usa facilmente por el conveniencia ultima. La mexcla tiene mas de 8,500 compresion cada pulgada cuadrado en 38 dias con solo agua. EnCOUNTER es una mexcla del concreto de piedra caliza aplastado que esta constuido con una mensula con exito cuando mexclas de arena no puede y no tiene que tener las juntas. A decir sencillomente, enCOUNTER e lo mejor mexcla moldeado en lugar en el planeta, y hace bien con aplicactiones precurado tambien! El producto esta disponible en colores de gris o blanco y acepta bien todos los metodoes de colorear incluso a tintes de del colores de concreto y pigmento liquido de enCOLOR, una familia de 15 colores con una grande extension de colores. La mexcla ofrece menos conjetura, mas conveniencia y lo mejor realizacion y fuerza.

Algunas de las habilidades que La Tienda de Estampas ensena son tecnicas por concreto eestampado y enchapado, tintiendo de acido y base de agua, haciendo muescas, estarcidos, tableros y guias de como empezar un negocio de concreto decorativo. Los estudiantes avanzados afilan los habilidades en revistimientos del concreto estampado hecho de polimero por concreto que ya existe, tintiendo de acido y base de aqua tableros y com mejorar su negocio de concreto decorativo.

El Fundador del negocio, Doug Bannister, ha sido concernido a los tratamientos del concreto decorativo desde 1980. Su primer empleo fue como contratista del concreto decorativo y luego continua hacer empleos al mismo tiempo, innovando nuevos productos de conreto.

Junto con Stan Pace, Bannister ayuda inventar el Sistema de Textura de Concreto Vertical "Fossilcrete" que ofrece un sistema vertical y las herramientas impresiones de tres dimensions ("3D") que ayudan a las contratistas y los artesanos crear las formas del arte que imitan el mundo natural, com los fisiles, huellas de animales, las plantas y la vida del mar. En 2006, FossilCrete estaba honrada con el premio mas prestgioso "Expert's Choice Most Innovative Products Award" en la categoria del concreto decorativo al programa del Mundo de Concreto en Las Vegas. Ahora, los productos de FossilCrete estan distribuido por toda la nacion y, por supuesto, por La Tienda de Estampas con los otros productos de concreto decorative de Bannister.

La Tienda de Estampas ofrece una linea completa de materiales de concreto decorativo, mantenido por la personal tecnico atentivos y profesional. Los productos incluyen instrumento del color para el concreto, los tintes del concreto, las herramientas texturas del concreto, las herramientas de acabar y los aditivos quimicos. El equipaje del concreto decorativo incluye (**vibratory screeds**), las sierras especiales y las herramientas.

Estos incluyen los sistemas del suelos interiores de concreto decorativo con tintes de acido, las capas de encima o los productos de mantener de concreto y los moldes de lavabos y fregederos, mexclas de concreto y los tintes. Tambien, incluye los materiales por applicaciones verticales de concreto como una cascada exterior o un chiminea interior, una pared de piedra rodeado o una ducha.

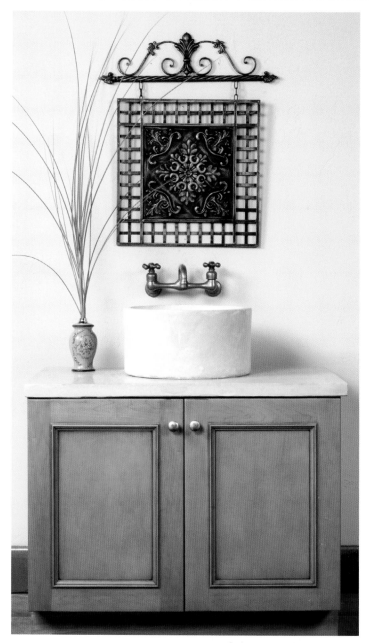

Hand-formed Sink and Slab Countertop

This project combines a basic, flat countertop with a central drain knockout, and a creative circular sink formed in a custom Styrofoam mold. We custom made this mold as a prototype for a model now available on the market. The prototype gave us a little difficulty when it came to extracting it. The new, market-ready model is self-releasing. However, it's important to understand that with ingenuity and patience, you can create almost any form that suits your design needs.

This very simple project is a perfect starter. The countertop was cast on a melamine base, with straight 1 ½-inch melamine strips forming the walls. It can easily be placed atop a piece of fine furniture, or a standard floor cabinet. This piece, once complete, will rest on a standard floor cabinet or could be used to cap a piece of furniture.

Un Tablero de Losa y Lavabo Moldeado a Mano

Este proyecto junta un tablero, basico y plano con un sumidero central (knockout), y un lavabo circular y original moldeado en un molde especial de stirofoma. Nosotros hicimos este molde como prototipo de un modelo que ya esta disponible. El prototipo estaba un poco dificil a extraer. El nuevo, modelo que esta listo para vender esta soltado de su propio modo. De qualquier modo, es importante a comprender que con paciencia y ingenio, puede crear casi cualquier molde que esta apropriada para su necesitos de deseno. Este proyecto sencillo es perfecto para empezar. El tablero estaba moldeado en un base de melamina, con estrechas tiras del melamina del tamano 1 ½ pulgadas para formar las paredes. Puede poner facilmente sobre un muebles de buena calidad o un armario usual de suelo. Este proyecto, cuando termindado, puede pesar sobre un armario usual del suelo o encima de un muebles.

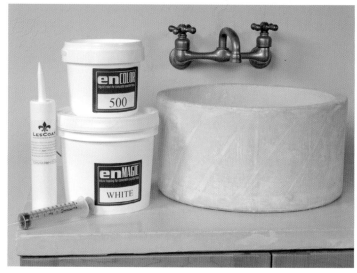

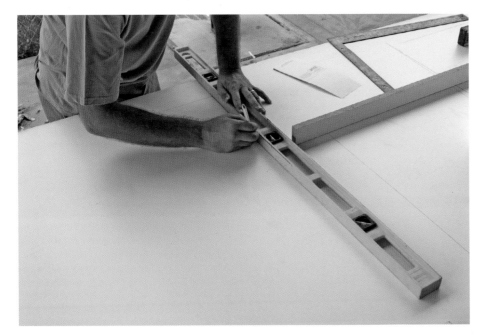

The outside dimensions of a counter-top are measured and marked on a flat piece of melamine board.

Los dimensiones de exterior estan medido y marcado en una pieza de tabla de melamina.

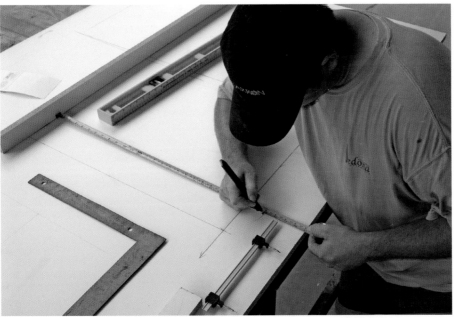

Important tools to have on hand when creating a mold include a square, a level, and the patience to measure twice.

Algunas herramientas para tener cuando crear un molde incluye un cuadrado, un nivel y la paciencia a medir dos veces.

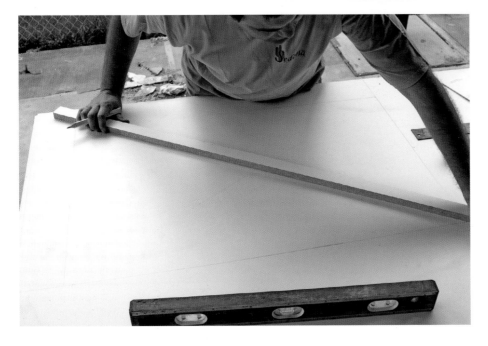

The center point of the counter is found by creating diagonal lines from the corners.

Encuentra el punto central por crear dos lineas diagonales desde las esquinas.

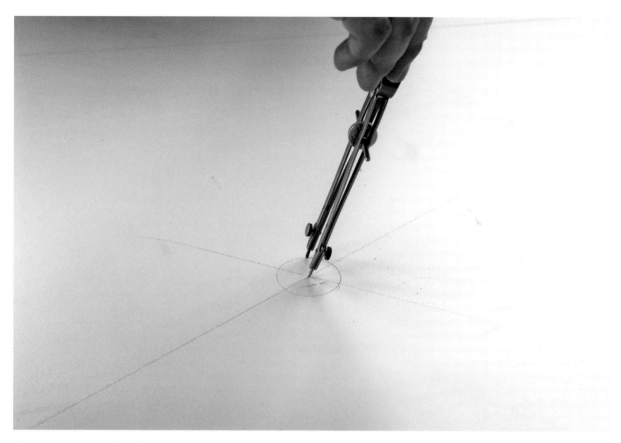

A compass traces the diameter of the drain knockout in the center of the counter.

Un compas delinea el diametro del (knockout) del sumidero al centro del tablero.

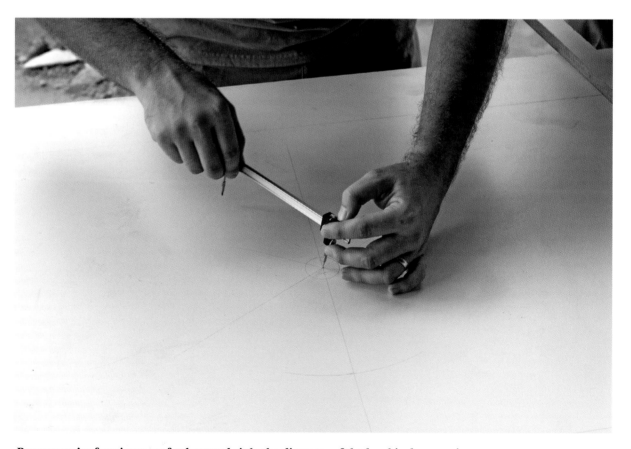

Because we're forming a perfectly round sink, the diameter of the bowl is drawn using a compass.

Porque el lavabo sera perfectamente rodundo, usa un compas para medir el diametro.

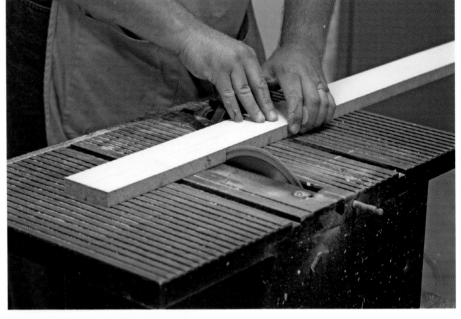

Melamine board is cut on a table saw to 1-1/2 inches wide to form the walls of the mold.

Corta una tabla de melamina en una sierra de mesa a 1-1/2 pulgadas de ancho para formar las paredes del molde.

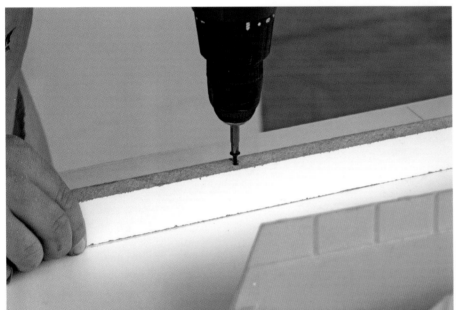

The strips are then affixed to the melamine base of the mold. The screws are sunk below the edge of the mold in order to ensure a smooth screed surface.

Pegan las tiras al base de melamina del molde. Atornilla los tornillos abajo del borde del molde para asegurar un superficie liso y (screed).

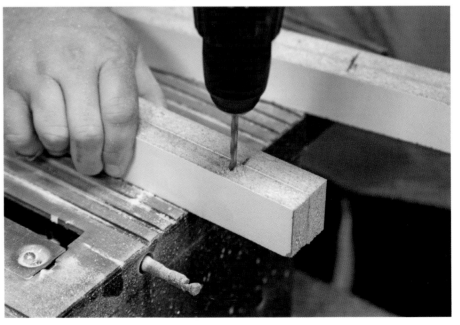

... and holes are pre-drilled at the marks.

. . . y perforan antes los huecos a las marcas.

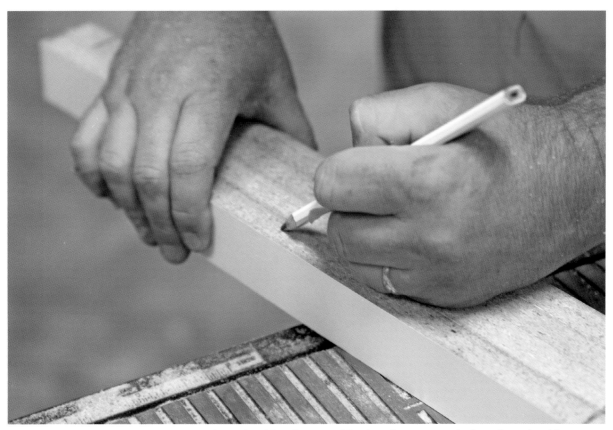

These strips are then cut to length to form the sides, front, and back. Points are marked on the strip sides ...

Corta estas tiras a medida para formar los lados, el frente y los partes delatantera y de atras. Marca los puntos en los lados del las tiras . . .

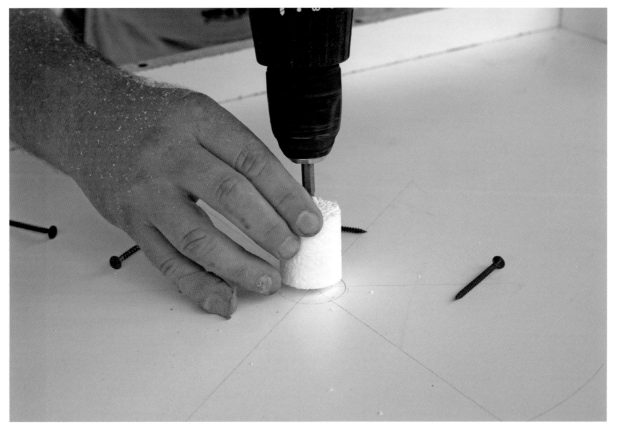

A foam piece, the diameter of the drain, and the height of the countertop (1 1/2'' tall) is affixed with a screw to the mold.

Pega na pieza de espuma el mismo diametro del sumidero, y la altura del tablero (1 ½ " de altura) con un tornillo al molde.

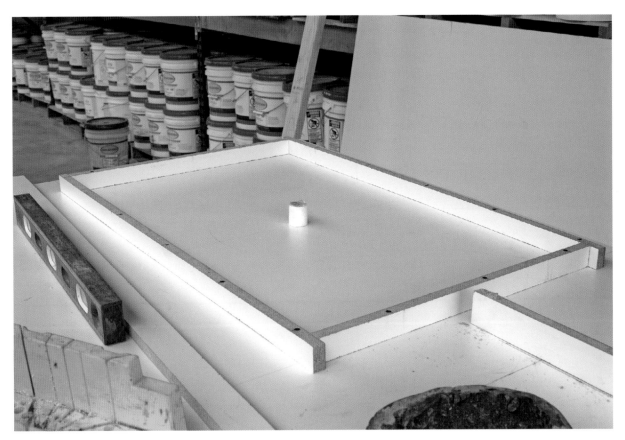

The finished mold.

El molde terminado.

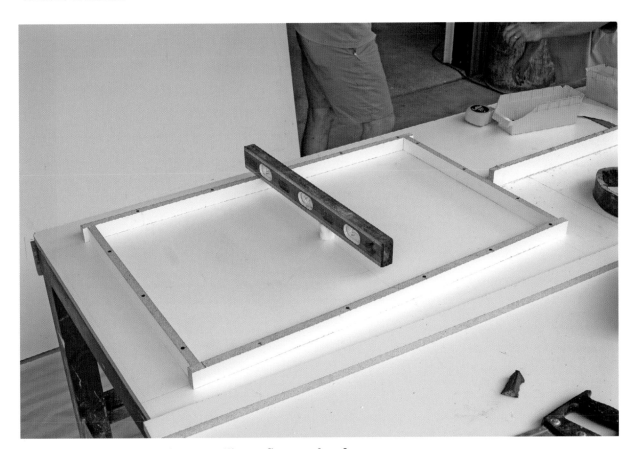

The level is checked to make sure we'll get a flat screed surface.

Examina el nivel para asegurar un superficie plano y (screed).

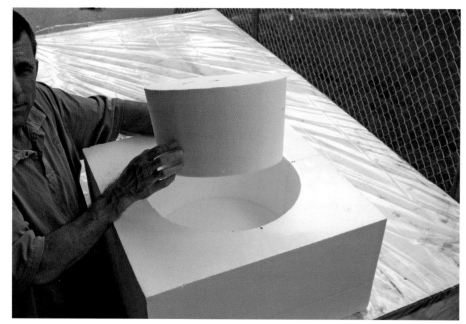

A prototype sink mold has been created from Styrofoam. The reservoir sits within four square pieces of foam glued together. The insert will rest an equal inch from either side of the reservoir.

Un molde de lavabo prototipo ha sido creado de "Styrofoama". El deposito esta entre cuatro piezas de espuma que estan pegado juntos. El inserto va a quedar una pulgada de cada lado del deposito.

The drain knock-out will fit in the drain hole provided, exactly 1 inch high. The knockout tube will extend from the reservoir up through the basin mold…

El (knockout) del sumidero va a ajustar en el hueco de sumidero, exactamente una pulgada de altura. El tubo (de knockhout) va a extender del deposito hasta el molde de la pila . . .

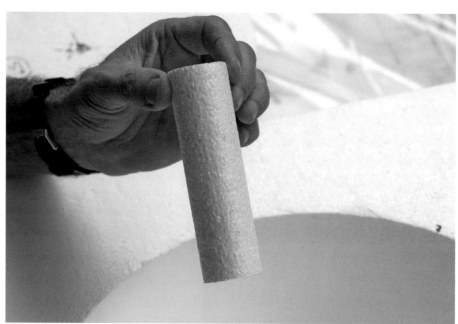

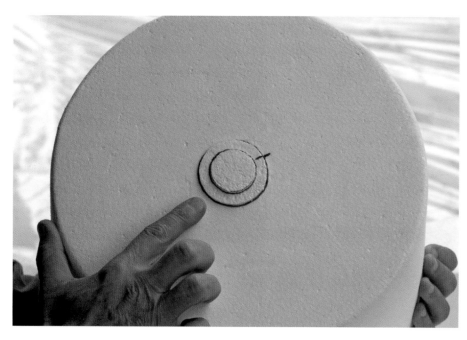

… like so.

. . . como asi.

Four spacers will maintain the 1-inch equal distance all the way around for the basin insert from the reservoir mold. The spacers have been numbered and aligned at four even points around the mold.

Cuatro espaciadores mantiene la distancia iqual todo alrededor para la insercion de pila del molde del deposito. Las espaciadores tiene numeros y estan de unas distancias iguales alrededor del molde.

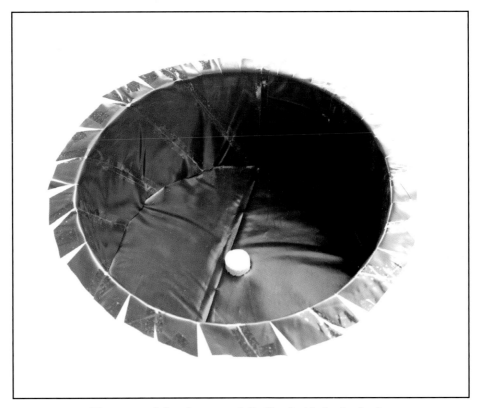

The reservoir has been carefully lined with 6 ml. plastic.

Reviste el deposito cuidadosamente con plastico de 6 ml.

Likewise, the basin mold has been shrink wrapped in plastic to ease the mold's release after casting.

Iqualmente, el molde de pila ha sido empaquetado en plastico para que se hace mas facil a libertar el molde despues de moldear.

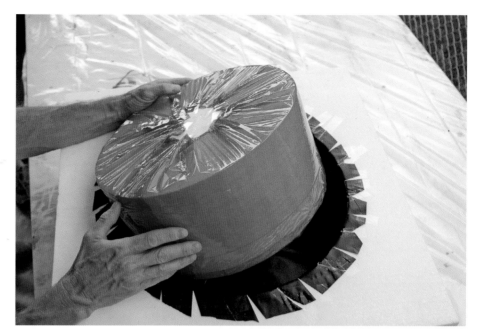

The spacer blocks can be raised during the pour by attached wires.

Los soportes de espaciadores pueden estar levantado durante del diluvio por los alambres ligados.

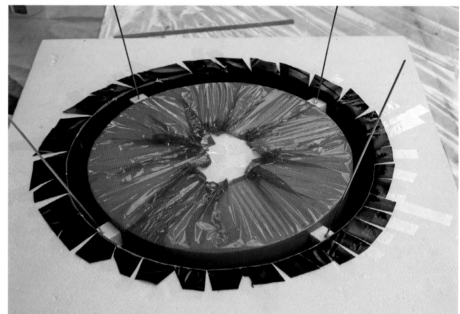

The sink mold is anchored to a base for "the pour" using scraps of wood.

Asegura el molde del lavabo a un base durante del "diluvio" usando trozos de madera.

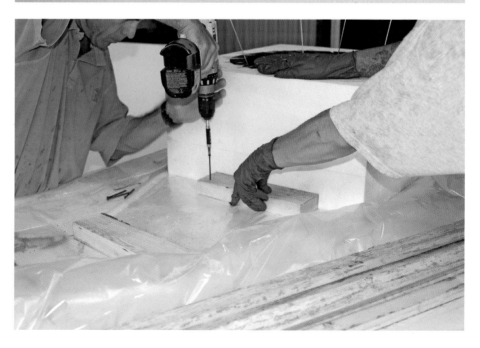

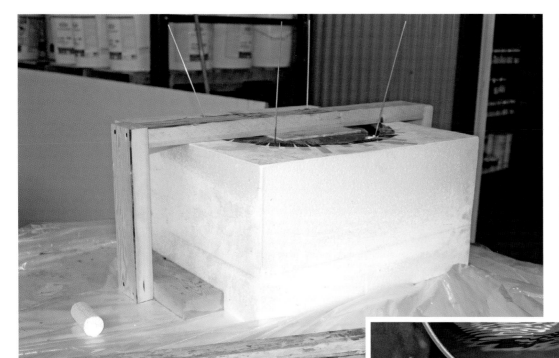

A wooden cap has been screwed down over the mold to prevent the basin mold from floating up during the pour.

Pone una tapa de madera sobre el molde para preventar el molde de pila de hacer flotar durante del diluvio.

Keeping water out of concrete makes it more durable and minimizes cracks. It is critical that the water be measured exactly. We start with 80 ounces of water per bag, and then add 2 ounces per bag at a time, not to exceed 90 ounces.

Mantener el agua fuera del concreto hace que sea mas durable y minimize las estrelladuras. Es critico que el agua sea medida exacta mente. Empezamos con 80 onzas de aqua por bulto. Y luego se agrega 2 onzas por bulto a la vez; no excederce arriva de 90 onzas.

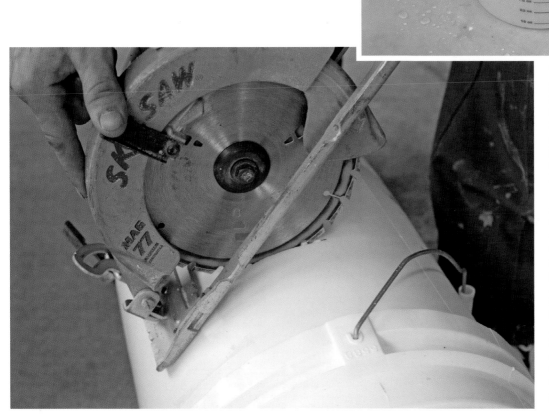

This pre-measured water is poured into a work bucket, then the line is marked and a slit is cut in the side with a circular saw for fool-proof measuring. For instance, four bags are usually mixed at a time, so mark the bucket at 320 ounces.

Esta medida de aqua es vaciada adentro del vote del trabajo. Luego la linea es marcada y cortada en un lado con una cegeta circular para una medida de prueba. Por ejemplo 4 costales son usualmente mezcladoz a la vez; asi se marca el vote a 320 onzas., cada bolsa, y medimos 2 onzas cada bolsa, cada vez. Mide el agua, 80 onzas cada bolsa de mexcla de enCOUNTER en un cubo plastico.

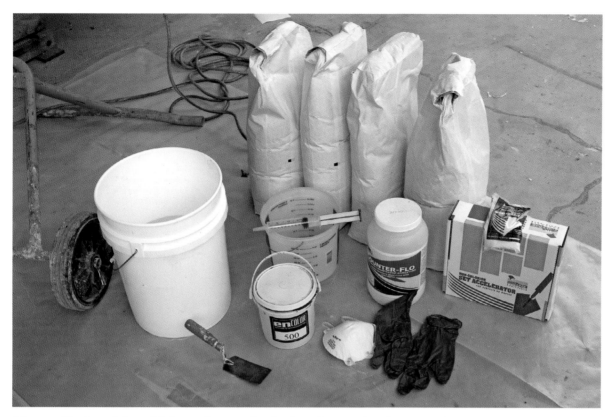

The supplies for mixing: Mixing and measuring buckets, face masks, gloves, enCOUNTER concrete mix, en-COLOR, syringe (comes with color), accelerator, small bucket, and a margin trowel. Also, it's important to mix with a mixer, preferably a metal drum – it's easier to clean. You loose 1,000 pounds per square inch of strength if you mix by hand. In all, it costs $10-12 per square foot for all the materials, including color.

Los provisiones para mexclar: Cubos para mexclar y medir, los antifaces, los guantes, mexcla de concreto "enCOUNTER", una jeringa (ya viene con color), un catalizador, un cubo pequeno y una llana del margen. Tambien, es importante a mexclar con una mexcladora, mejor barril de metal. Pierde 1,000 libras cada onza cuadrado de esfuerza si mexle a mano. A todo, cuesta $10-12 dolares cada pie cuadrado por todo los materiales, incluso el color.

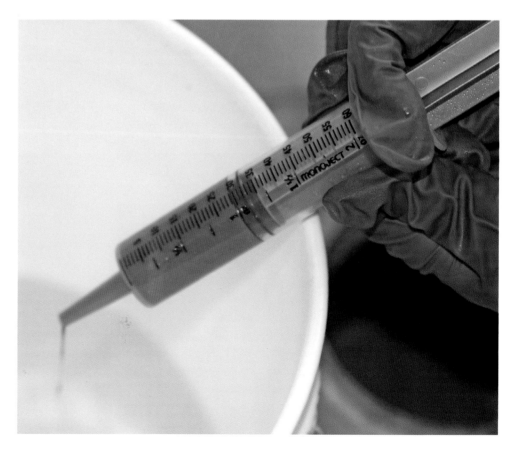

One-quarter ounce of green en-COLOR is added per bag.

Anade un cuatro onza de enCOLOR verde, cada bolsa.

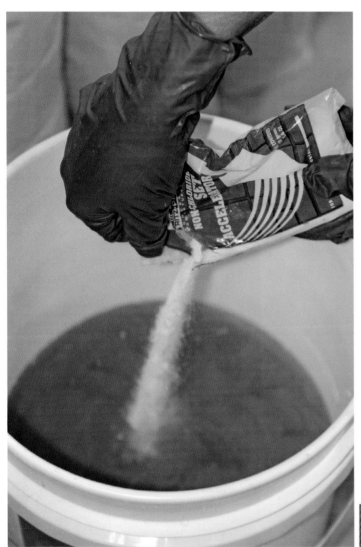

Some water is removed from the pre-measured bucket. We add one package of accelerator per bag when we want a faster set time.

Quita algun agua del cubo premedido. Anade un paguete de catalizador cada bolsa para que secar mas rapido.

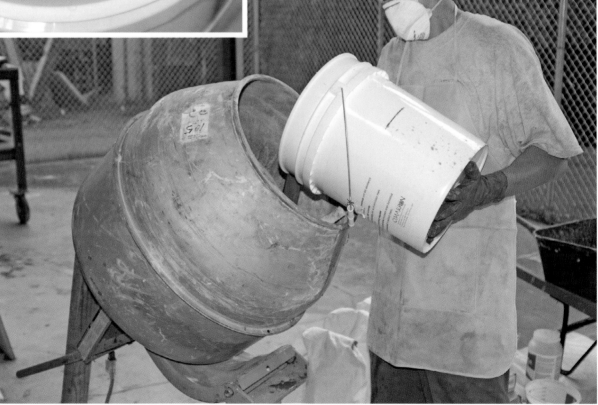

The enCOLOR and accelerator are blended in the bucket, then added to the mixer …

El enCOLOR y el catalizador estan mexclada en el cubo y luego anaden a la mexcladora…

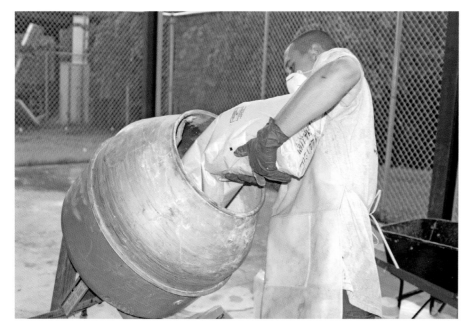

... along with the first three bags of enCOUNTER mix.

. . . con las tres primeras bolsas de mexcla de enCOUNTER.

Mix this, stopping to scrape the sides of drum with a scraper. The final bag of enCOUNTER is added, then mixed for approximately 10 minutes, stopping occasionally to scrape interior with a margin trowel.

Mexcla este conjunto, pero para a veces para limpiar los lados del barril con un rascador. Anade la bolsa final de enCOUNTER, y luego mexcla por aproximamente 10 minutos, parando a veces para limpiar el interior con la llana del margen.

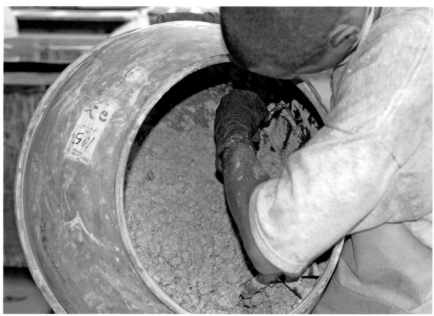

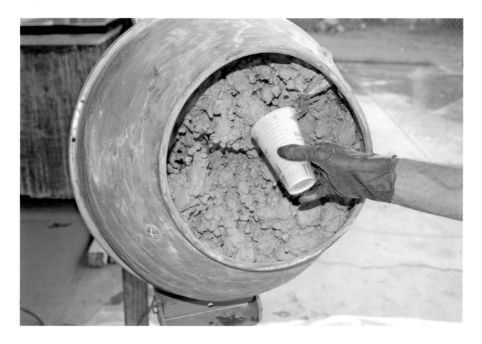

At this point, inexperienced people would start to add water. It's important to maintain the discipline. Additional water should be added in increments of 2 ounces of water per bag. Never exceed 90 ounces of water per bag.

En este momento, una persona sin experiencia empezara anadir el aqua. Es importante mantenga la disciplina. Tiene que anadir mas agua en incrementos de dos onzas de agua cada bolsa. Nunca excede mas de 90 onzas de agua cada bolsa.

It will begin to fall off the paddles like bread dough.

Empieza caer do las paletas como masa de pan.

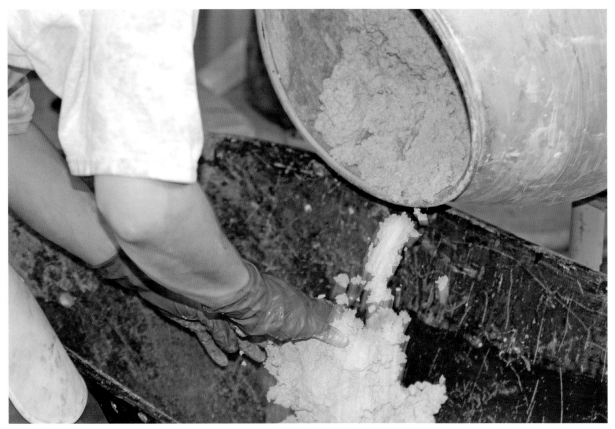

The concrete is then transferred to a wheelbarrow, ready for packing the molds.

Traslada el concreto a una carretilla, lista para llenar los moldes.

The first ¾ of an inch are added first to mold. It is important to make sure that the corners are firmly packed.

Las primeras 3/4 de una pulgada estan anadido al primer molde. Es importante asegurar a llenar las esquinas muy bien.

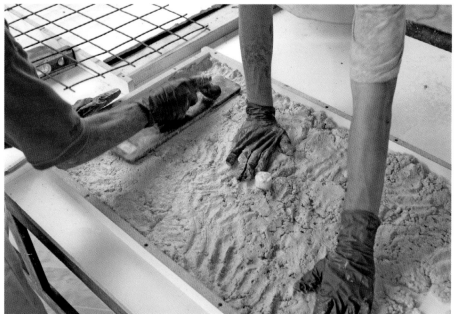

Fill the entire mold to a fairly consistent depth, in this case halfway up the mold edges.

Llena el molde total a un fondo consistente, en esta situacion, al mitad del lado.

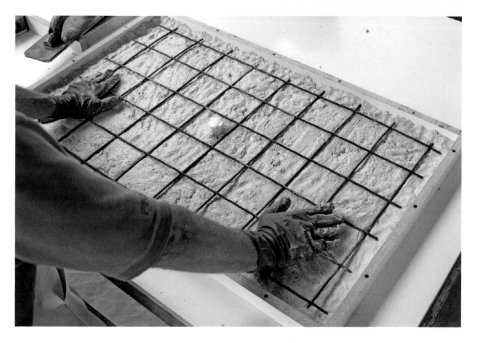

The pre-cut reinforcement, 4 x 4 x 6 gauge wire is laid in.

Pone el alambre tamano 4 x 4 x 6 de armazon.

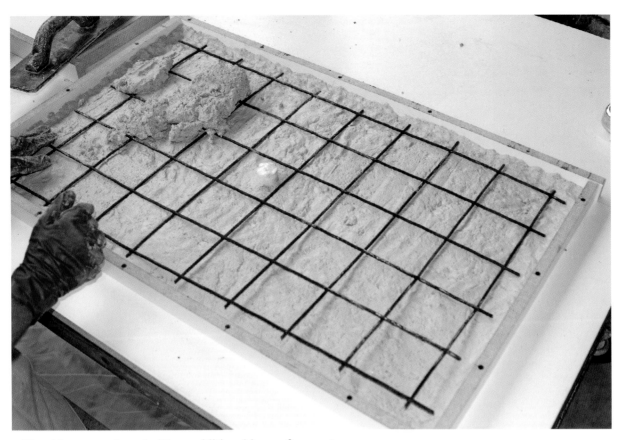

The sides are anchored with an additional layer of concrete.

Los lados estan asegurado con otra capa de concreto.

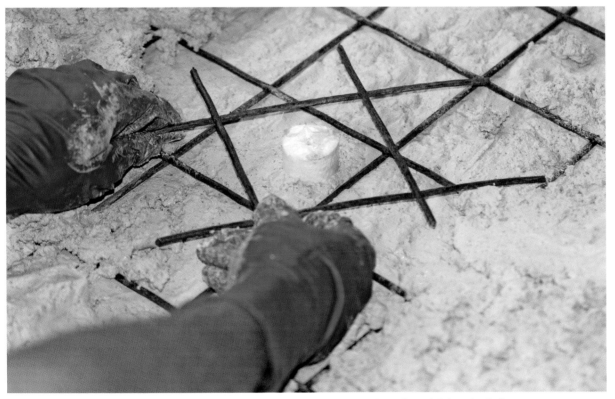

An angled piece of 4 x 4 x 6 gauge wire is laid over the drain knockout for additional reinforcement.

Se pone una pieza de alambre, puso en angulo, del tamano 4 x 4 x 6 sobre el (knockout) del sumidero por armazones adicionales.

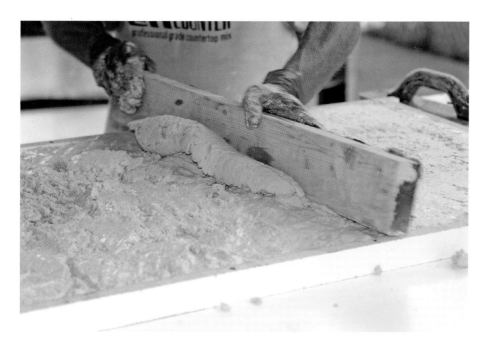

The mold is filled and a screed board drawn back and forth across the form.

Llena el molde y ir y venir atraves el molde con (screed board).

An orbital sander is used to vibrate the walls of the mold on top...

Usa una lijadora orbital para vibrar del molde de parte de arriba . . .

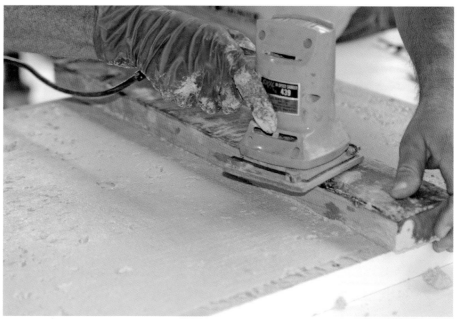

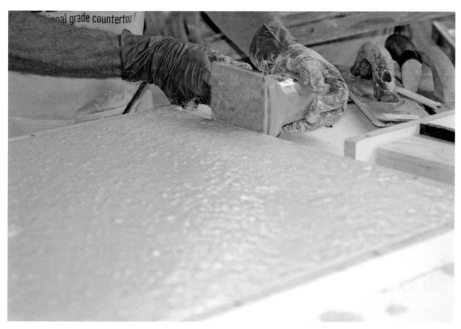

... and on the sides of the mold walls to pack the material. The vibrator is also applied underneath the worktable.

. . . y en los lados el molde para llenar el material. Tambien, usa el vibrador debajo de la mesa del trabajo.

The vibrated surface ready for finishing.

El superficie vibrado ya esta listo para acabar.

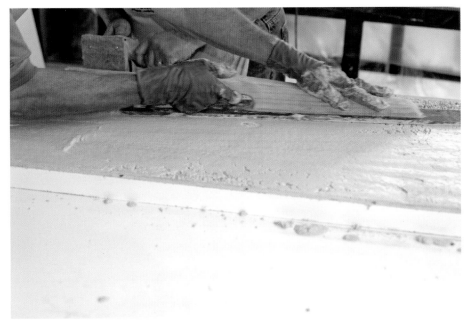

A wooden darby opens the surface and lets a little more water out.

Una flota de madera abre el superficie y permite salir un poco de aqua.

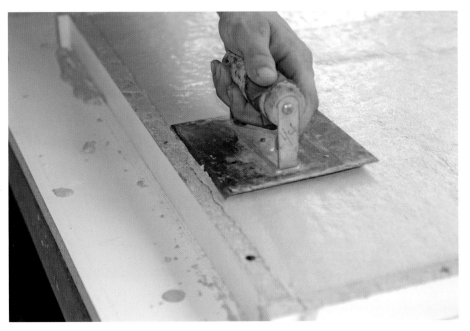

An orilla is used to create a clean line against the edge mold.

Usa un (edger) para crear una linea limpia atras del borde del molde.

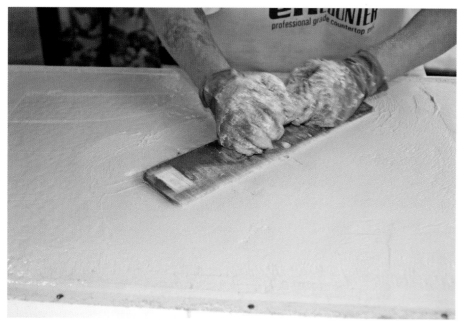

A hand float prepares the surface for the next step, troweling. The counter is then allowed to cure overnight.

Un flotador de madera abre las superficies y deja que un poco de agua salga hacia a fuera. Permite curar el tablero por la noche.

The base of the sink mold is packed to the level of the sink knockout, and vibrated. The basin mold is then inserted with spacers and the support bar to keep it from floating up.

La base del molde del fregader es llenada y brivado al nivel del (knockout) fregadero el recipiente del molde es entonces insertado con espacios y suporte de la barra para mantenerlo estable y que no flote para arriba.

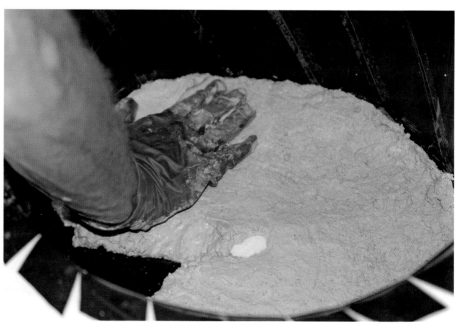

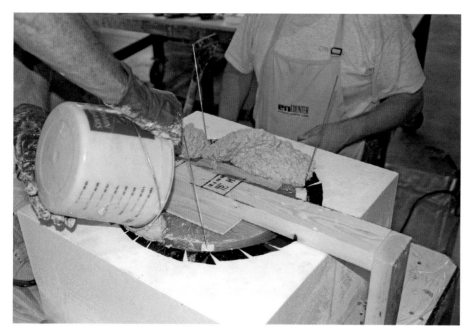

Counter-Flo is added to the remaining mix to help it flow into the sink mold.

Aditivo de la cocina integral es agregado a la mezcla que ha sido mezclada para ayudarle a flotar adentro del molde sumergido.

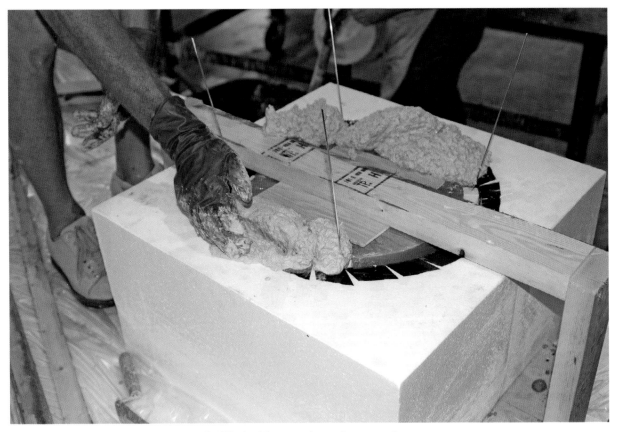

The bottom of the sink receptacle is filled with a gruel-consistency mix.

Llena el fondo del receptaculo del lavabo con una mexcla que es la consistencia de gachas.

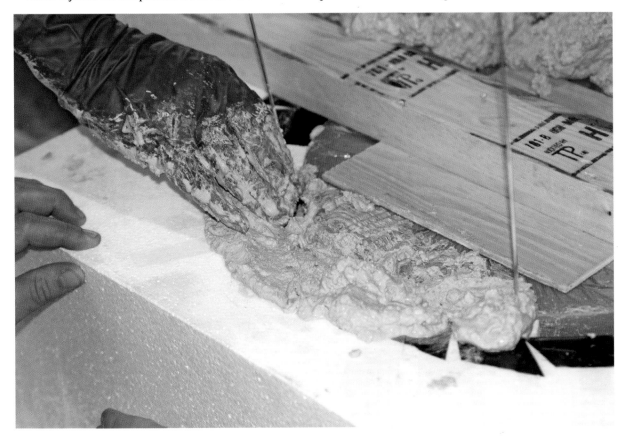

Fingers help work the mix into the void.

Los dedos son utiles par llenar la mexcla al vacio.

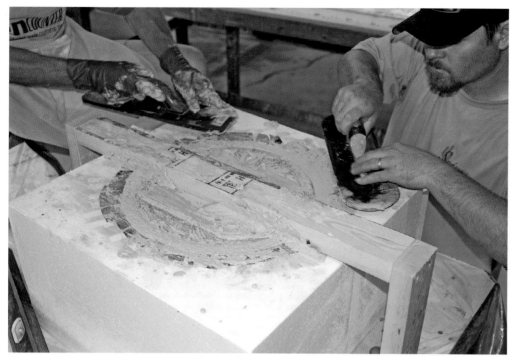

A vibrator ensures its even distribution. Careful trowelling finishes off the lip at the top of the sink. The spacers are removed, and the crossbar, to allow a final packing and trowelled finish on the surface. It is then allowed to cure overnight.

Un vibrador asegura una distribucion lisa. Extendiendo la llana cuidadosamente acaba el labio al parte de arriba del lavabo. Quita los espacioadores y la barra para permite un llenando final y acabado de la llana en el superficie. Permite curar por la noche.

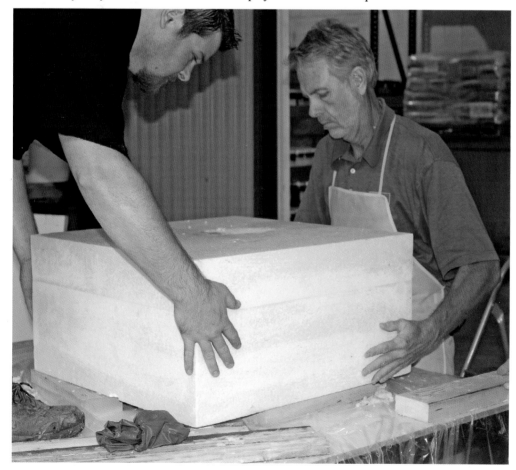

The next day, the sink mold is turned upside down, supported by 2 x 4s.

El proximo dia, el molde del lavabo se pone al reves, suportable por 2 x 4s.

The reservoir mold is removed.

Quita el molde del deposito.

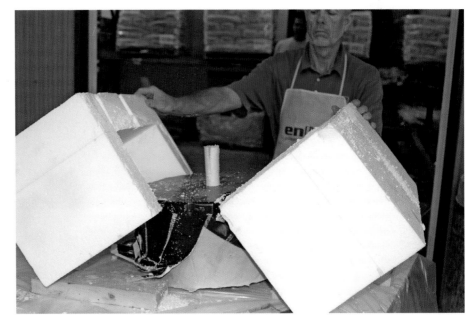

The plastic comes away to reveal a sink still quite warm and green. It cured slowly in its thickly insulated mold.

Cuando quita el plastico, se ve un lavabo bastante calido y verde. Cura lentemente en su molde con aislamiento grueso.

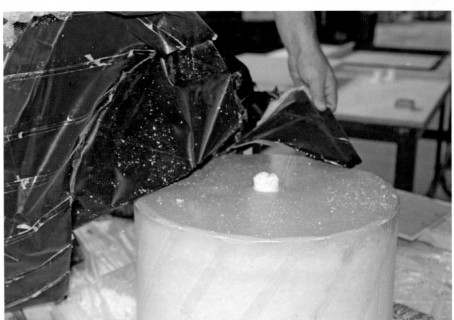

The foam mold inside the sink proves a little more challenging to remove.

El molde de espuma adentro del lavabo es un poco mas dificil a quitar.

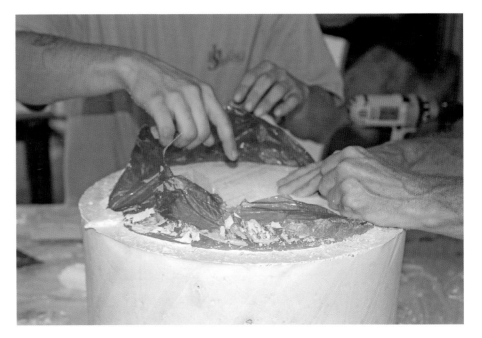

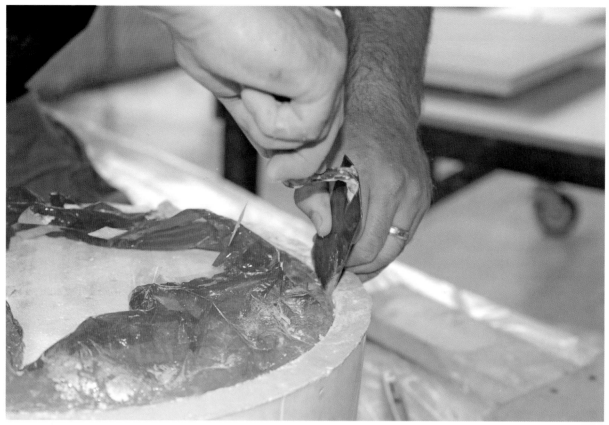

Any overlapping concrete is carefully chiseled away on the edge.

Acincela cuidadosamente algun concreto superpuesto en el borde.

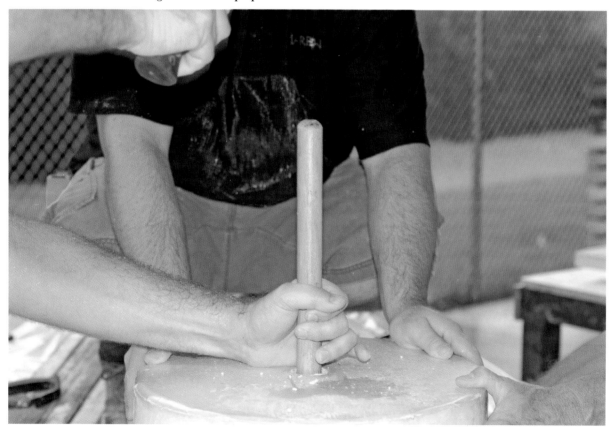

We turn the sink upside down and attempt, carefully, to pop the foam mold out with a dowel and hammer via the drain knockout. It doesn't work.

Pusimos el lavabo al reves y tratemos, cuidadosamente, quitar el molde de espuma con una clavija y un martillo, desde el (knockout) hasta el sumidero. No funciona bien.

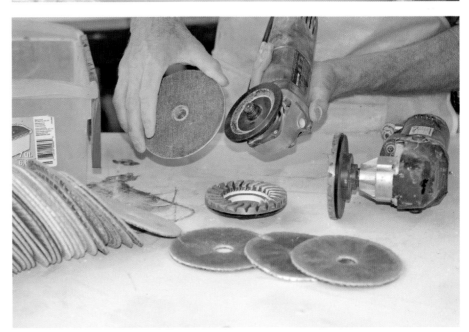

The next step is the hacksaw. We carefully cut away the foam form.

El proximo paso es la sierra para metales. Cuidadosamente, quita el molde de espuma.

The sink and counter will require lots of grinding. We'll want to use diamond pads that get progressively finer.

Necesita mucho pulvirizando en el lavabo y tablero. Es necesario usar cojines de diamantes, mas y mas finos.

Wet grind the surface of the counter lightly.

Pulviriza mojadosamente y lijadosamente el superficie del tablero.

And the edges.

Y los bordes.

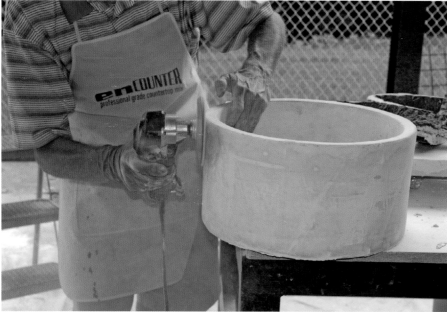

The sink mold gets the same treatment.

Hace lo mismo con el molde del lavabo.

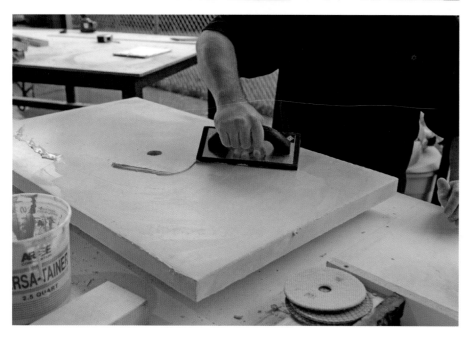

Use a rubber tile grout to spread a thin slurry of enMAGIC to fill the voids in the sink and countertop edges. Mix the slurry to a lighter shade because it will darken when waxed and sealed. The slurry is then trowelled on to the countertop surface, sides ...

Usa una flota de goma para extende una capa de enMAGIC un poco mas fino para llenar los vacios en los bordes del lavabo y tablero. Mexcla la capa de enMAGIC a una pinte mas claro porque oscurece cuando encerado y lacrado. La capa de enMAGIC esta extendido con la llana sobre los lados y el superficie del tablero . . .

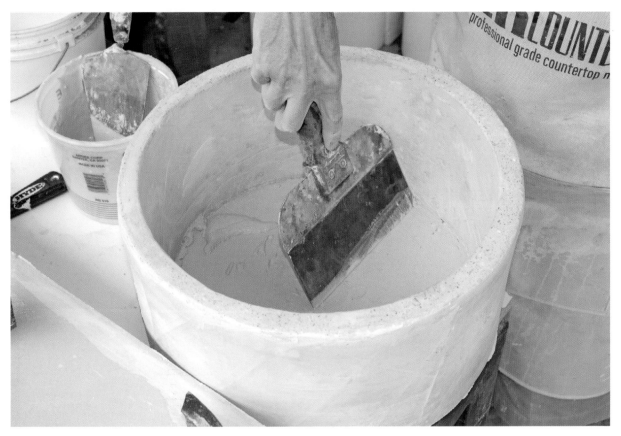

… and the sink.

. . . y el lavabo

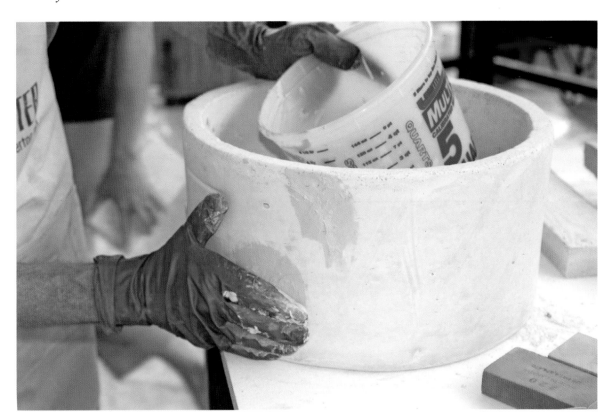

You may need to use your hands to treat the curved surfaces …

Es necesario usar las manos con los superficies curvados…

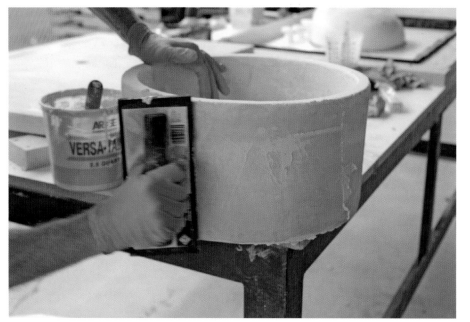

... as well as a trowel to smooth it.

. . . y una llan para alisarlo.

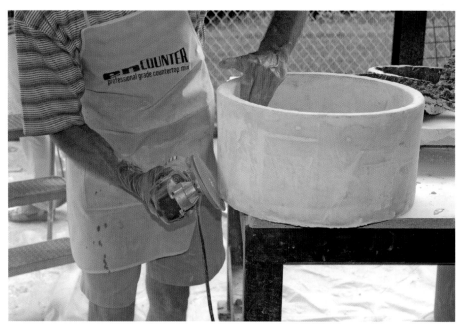

Allow to cure overnight. After the en-MAGIC has cured, sand or grind until you are satisfied with the finish.

Deja curar por la noche. Despues do curar, lija o pulviriza hasta que esta satisfecho con el acabado.

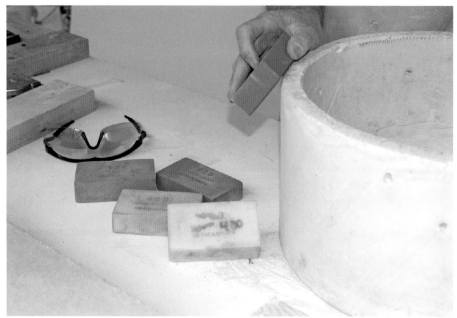

Some edges will have to be hand sanded. Expect the grinding stage to take well over an hour.

Es necesario lija a mano algunos bordes. Este tiempo de vulcanizar tarde mas de una hora.

After grinding, a penetrating sealer is applied. This sealer will not change the color, a water-based sealer will somewhat change it, and solvent will darken it dramatically. Doing samples is the best way to determine how it will look in the end.

Aplica un tinte penetrante. Este pinte no cambiara el color, un tinte de base de aqua, cambiara un poco, y un solvente oscurecere mucho. Hace muestras es lo mejor modo para saber come ve al fin.

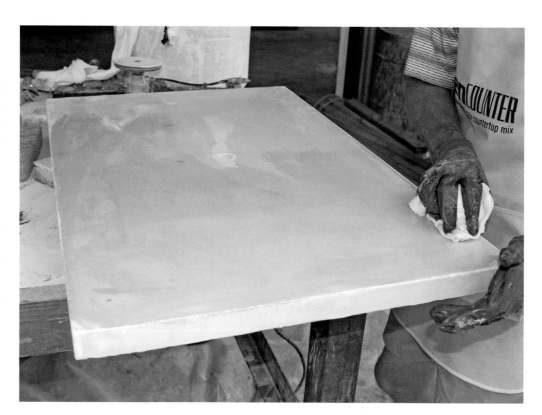

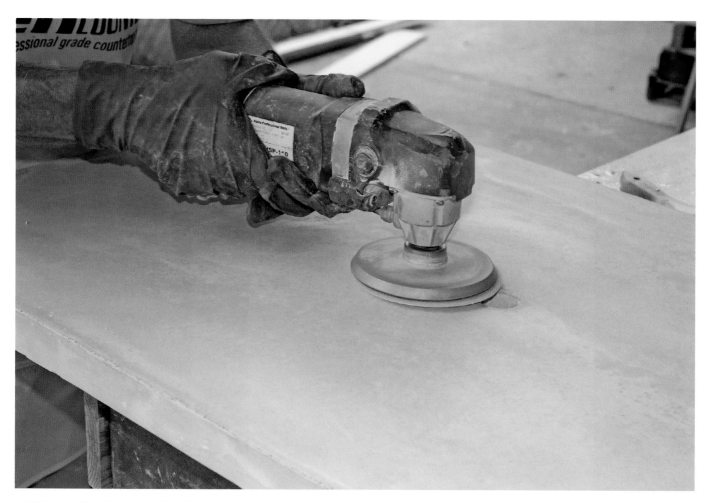

A light sanding then smoothes the surface.

Una lijada fina alisa el superficie.

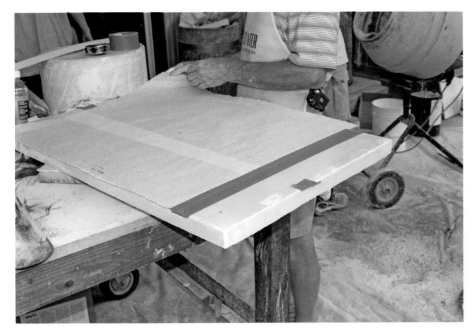

A special stencil is then positioned on the countertop and ...

Se pone un estarcido especial sobre el tablero y . . .

... the paper pulled back to reveal the stencil. You have to be careful when you pull not to stretch the plastic stencil and distort the shape.

. . . quita el papel para ver el estarcido. Quita con cuidado para que no estira el estarcido de plastico y cambia la forma.

The stencil openings are then carefully removed.

Quita las aberturas del estarcido cuidadosamente.

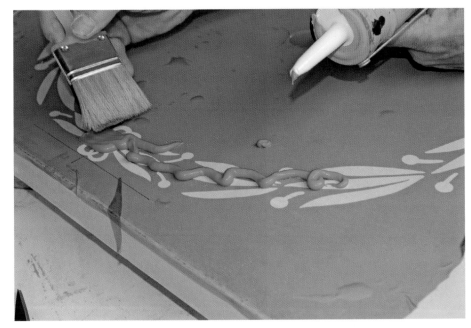

LesCoat product is generously poured over the stencil openings. LesCoat is a peel-able, stain-block coating.

Echa el producto LesCoat generosamente sobre las aberturas del estarcido. LesCoat es una capa que puede quitar y tambien prohibe manchas.

Carefully spread LesCoat over the stencil openings using a sponge brush.

Pone LesCoat sobre las aberturas usando un cepillo de esponja.

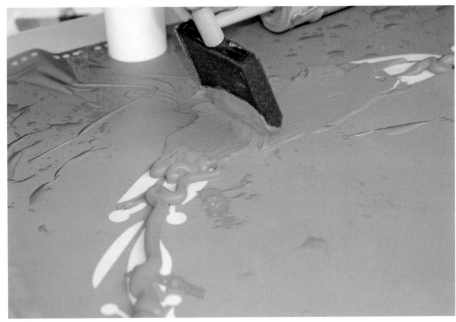

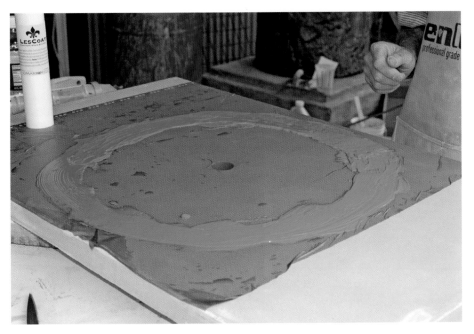

After the stencil is coated, ...

Despues de poner la capa sobre el estarcido, ...

... the stencil is then pulled back to reveal the protected design area and allowed to dry overnight.

... quita el estarcido para ver el area del deseno protejido. Dermimitido sobre la noche.

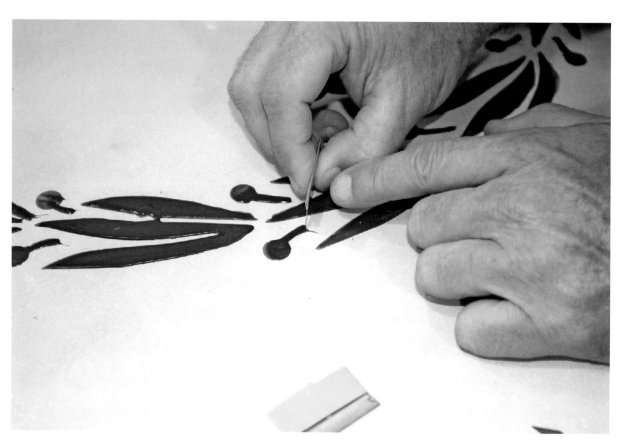

Small imperfections are easily removed with a razor blade.

Quita las imperfecciones pequenas con un cuchillo.

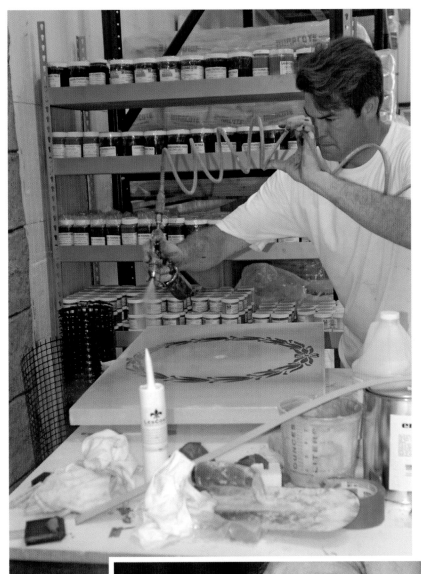

A stain is applied with an airbrush to create a subtle effect. Test your spray gun on paper before applying!

Aplica el tinte con un cepillo del aire para crear un resultado sutil. Antes de aplicar, prueba su pistola para pulvirizar en papel.

Here we have given it a very light treatment, leaving the stenciled pattern just barely discernable, as you can see with the stencil removed.

Aqui es un tratamiento fino que deja el patron de estarcido apenas discernible que puede ver cuando quita el estarcido.

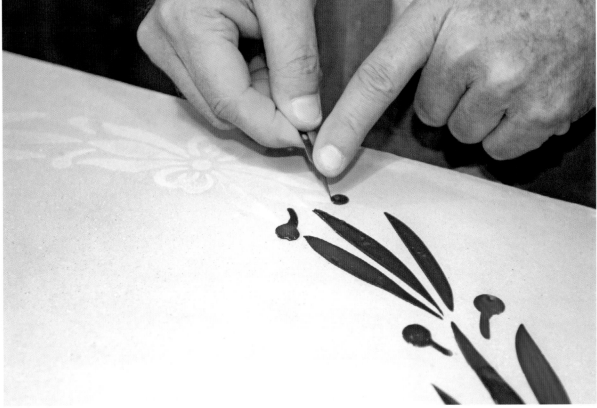

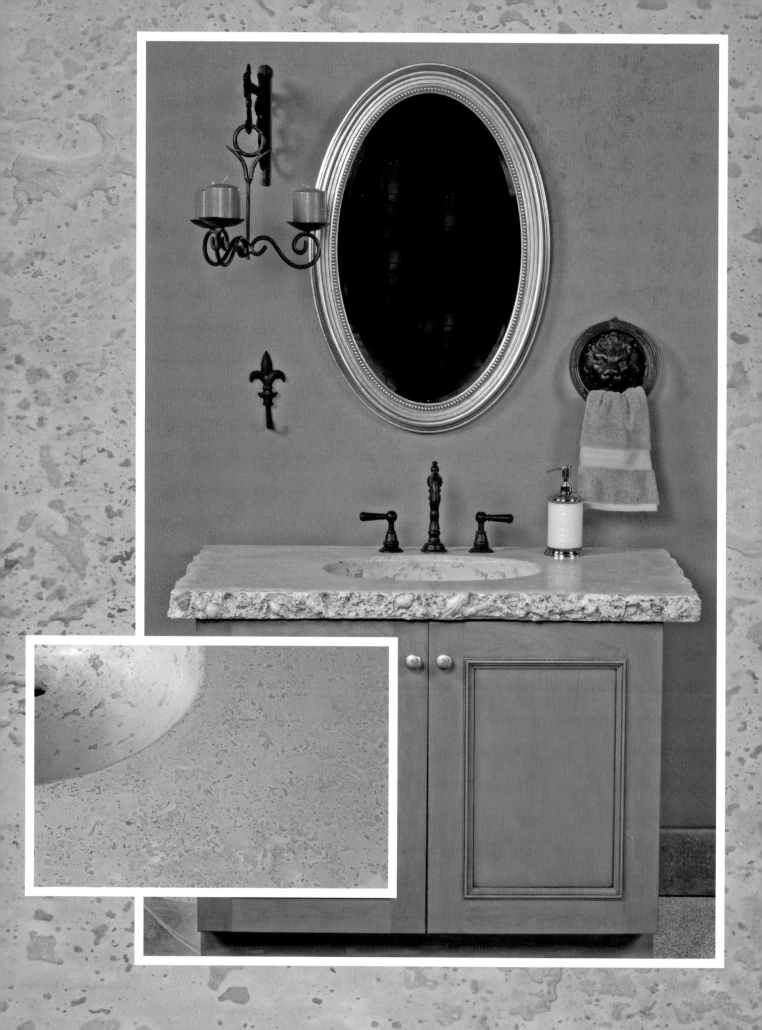

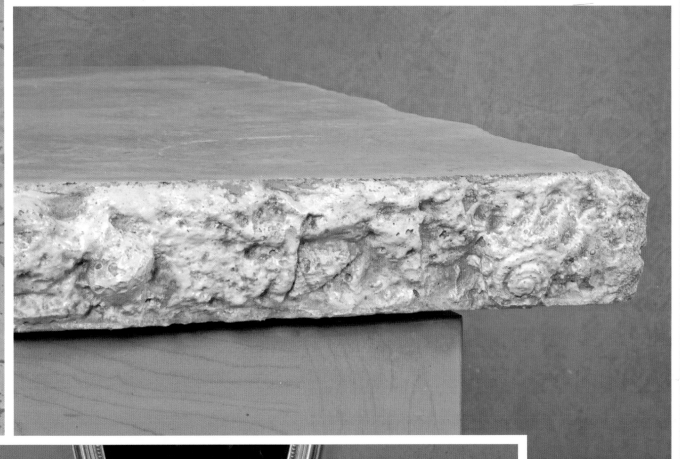

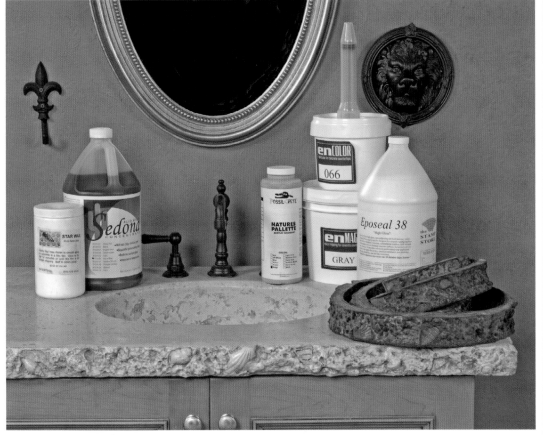

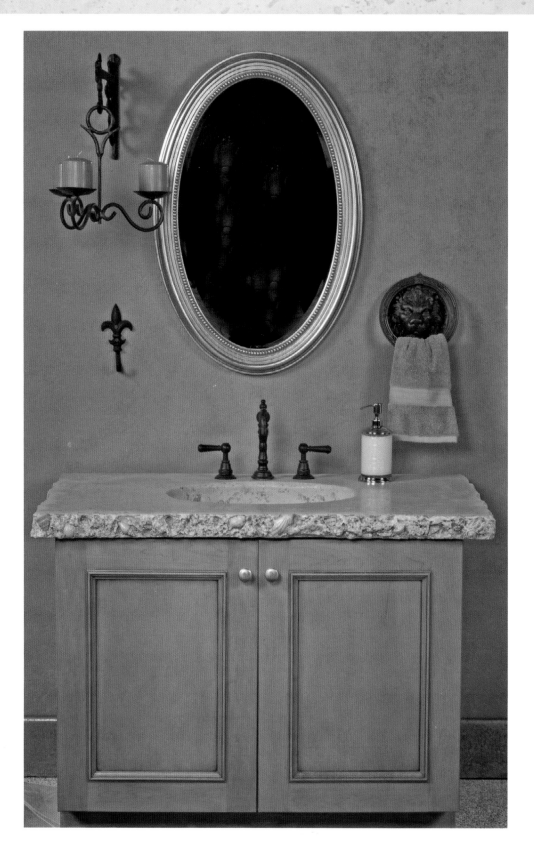

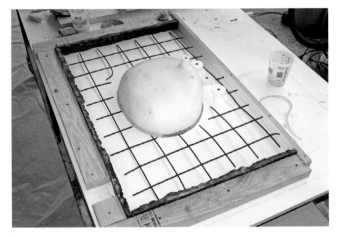

A fairly simple mold is made and ready to go. Reinforcement wire has been cut to fit.

Un molde bastante sencillo ha sido hecho y esta listo. Un alambre de armazon ha sido cortado a ajustar.

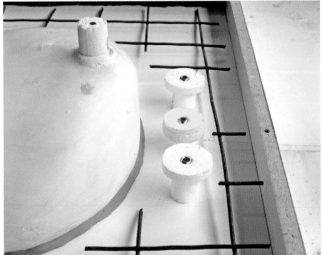

Knock-outs created from foam are in place for the faucet, handles, and a sink drain at the base of the sink. The sink mold was formed from carved Styrofoam coated with enMagic cement and sealed with wax and release agent. New vanity sink molds (enSINK) are available now at the Stamp Store.

La flojadura creada por la espuma estan puestos para las agarraderas de la llave, y un drenaje del fregadero en la base del fregadero. El molde del fregadero fue formado por la hechura de la insolacion de la espuma cubierto en el cemento ENmajico y sellado con cera. Los nuevos gavinetes de los moldes de fregadores (ENsink) estan ala venta ahora en la tienda de la Stamp Store.

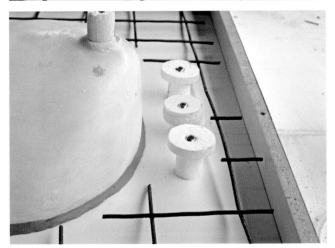

Red modeling clay (you can use any color), like that found at craft stores, has been used to seal the area at the base of the sink. Roll out pencil-thin "snakes" of the clay and then smooth in a uniform curve around the sink. This is then smoothed with release agent.

La arcilla roja (puede usar cualquier color), como la de las tiendas de artes, ha side usado para encerrar la seccion al base de lavabo. Desenrolla unos serpientes delgados como un lapiz de arcilla y despues alisa en una curva uniforme alrededor del lavabo. Alisa esta curva con (release agent).

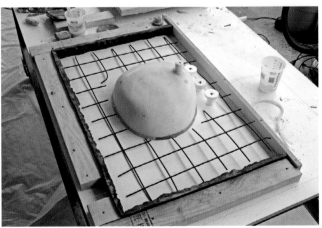

The front and sides of the mold are lined with self-releasing rubber rock and shell edge form, miter-cut for square edges. A light spray of sealer is applied around the entire counter area. Sealer should be applied thickly with a brush around the inner sink area to facilitate grout removal in the next step.

Reviste el frente y los lados del molde con (self releasing rubber rock) forma punta de concha, cortada de inglete para las puntas cuadradas. Una ruseada lijera de sellador es aplicada todo alrededor de la area del gabinete. El sellador debe de aplicarse gruesamente con una brocha alrededor de la parte de adentro de la area del fregadero para facilitar el removimiento en el siguiente paso.

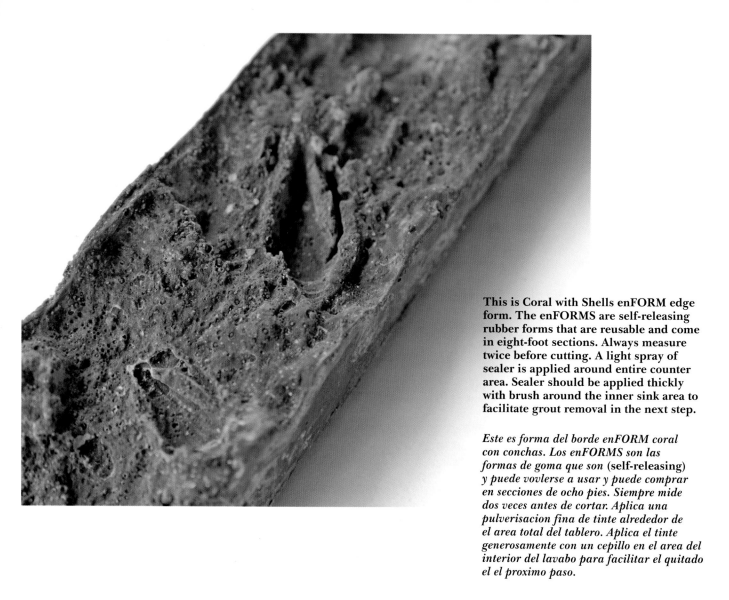

This is Coral with Shells enFORM edge form. The enFORMS are self-releasing rubber forms that are reusable and come in eight-foot sections. Always measure twice before cutting. A light spray of sealer is applied around entire counter area. Sealer should be applied thickly with brush around the inner sink area to facilitate grout removal in the next step.

Este es forma del borde enFORM coral con conchas. Los enFORMS son las formas de goma que son (self-releasing) y puede vovlerse a usar y puede comprar en secciones de ocho pies. Siempre mide dos veces antes de cortar. Aplica una pulverisacion fina de tinte alrededor de el area total del tablero. Aplica el tinte generosamente con un cepillo en el area del interior del lavabo para facilitar el quitado el el proximo paso.

Small wads of clay are pressed firmly into the mold, starting at the base of the sink…

Unas piezas pequenas de arcilla estan comprimidos firmemente al molde, empezando al base del lavabo . . .

... and working up.

. . . y mas arriba.

Press the dough-like concrete mix firmly against the walls of the mold before filling the base.

Comprime la mexcla del concreto que es parecido a masa de pan, firmemente contra las paredes del molde antes de llenando el base.

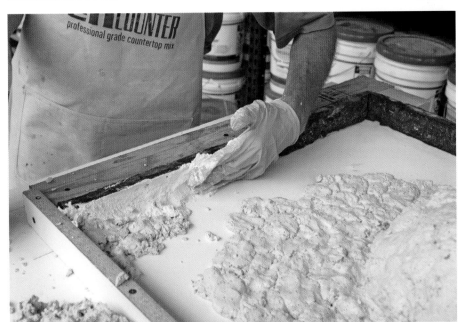

The goal is to create an irregular surface. Make the small pieces you apply inconsistent in terms of size and shape. You want to avoid creating a pattern on the surface.

El objetivo es crear un superficie iregular. Aplica piezas pequenas y inconsistente en tamano y forma. No quiere un patron al superficie.

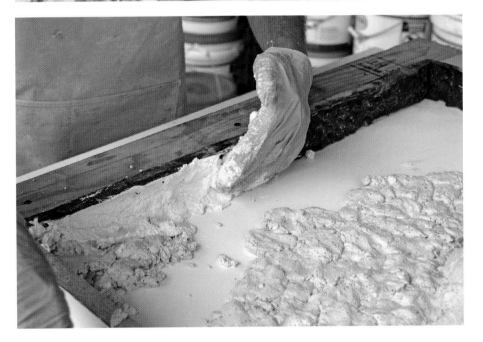

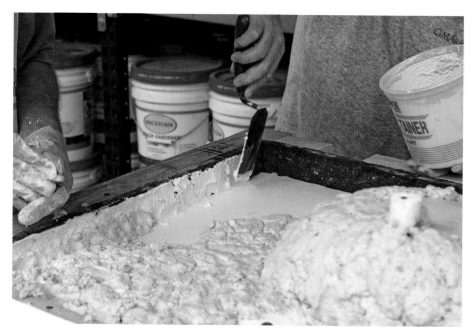

A slurry of white color hardener is added around the rubber mold.

Combina una capa de enduricdo blanco en color alrededor del molde de goma.

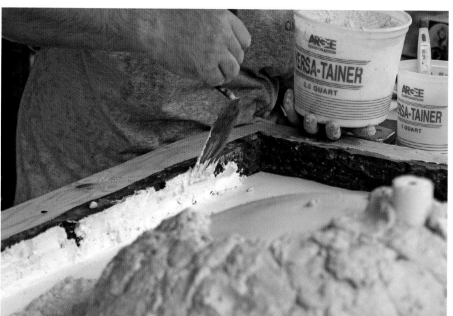

This slurry is worked into the rubber mold on all three sides of the vanity counter that will be on display after installation.

Llena esta capa en el molde de goma en los tres lados del tablero de tocador que estara en exhibicion despues de instalacion.

The edge is then packed in by hand with the concrete mix.

Llena el borde a mano con la mexcla de concreto.

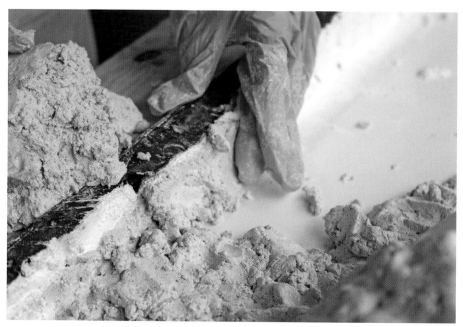

Use your fingers to get a nice pack.

Usa los dedos para llenar bien.

The base of the mold, soon to be the top of the counter, is then packed over the entire surface in the same manner. The result will be an uneven layer, approximately 3/4 inch thick.

Llena el base del molde que sera temprano el parte de arriba del tablero, sobre el superficie entero del misma manera. El resultado es un capa iregular, aproximamente 3/4 pulgadas de grueso.

After the first layer is in place, Counter-Flo is added to act as a wedding agent when the second layer is applied. A drainage tube is added between first and second layers, driven into the foam knock-out and the foam mold.

Anade Counter-Flo como segunda capa para ser (wedding agent) despues ha puesto la primera capa. Anade un tubo de desague entre la primera y segunda capa, puesto firmemente en el (knockout) de espuma y el molde de espuma.

The tube is anchored with concrete.

El tubo esta asegurado con el concreto.

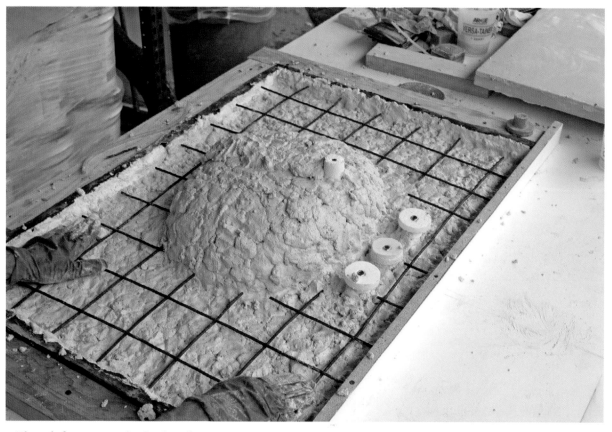

The reinforcement wire is placed.

So pone el alambre de armazon.

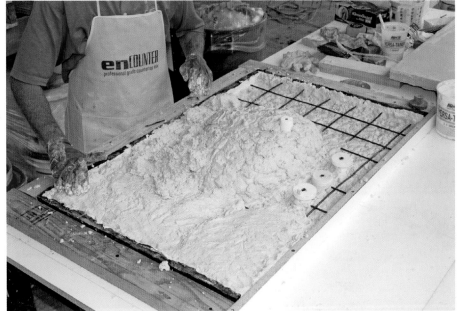

The second layer of encounter concrete is then added, filling the mold.

Anade la segunda capa de concreto "enCOUNTER", llenando el molde.

Use your fingers to clear away concrete from knockouts and then mark the holes with blue tape to prevent paste from filling the screw heads.

Usa los dedos para quitar el concreto de las flojaduras y despues marca los huecos con cinta azul para prohibir las pasta de llenar las cabezas de los tornillos.

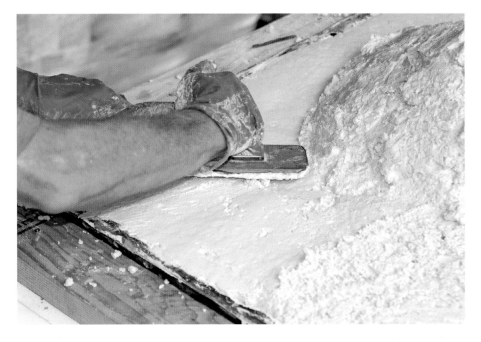

Now the bottom is trowelled to ensure an even pack. Finishing the bottom, it is important that it be level to sit on its furnishing, though the overall appearance is not that important. You don't want to work it too much, or a lot of detail on the surface will be lost.

Ahora, extende el fondo con una llana para asegura un llenado plano. Cuando acaba el fondo, es importante qu es nivel, aunque como se aparece no es muy importante. No quiere gastar mucho trabajo o se pierde muchos detalles en el superficie.

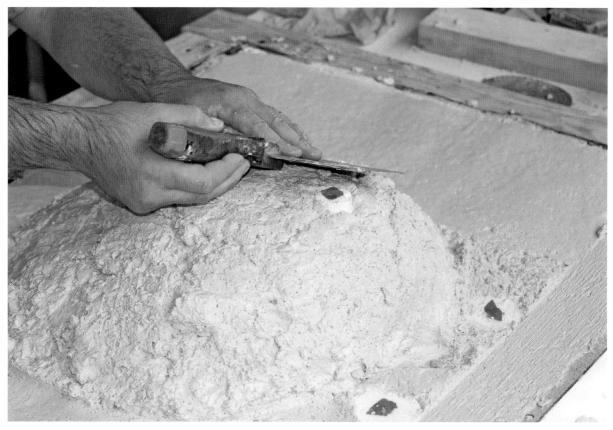

The bottom of the sink is carefully finished around the knockouts using a putty knife.

Acaba cuidadosamente el fondo del lavabo alrededor de las flojaduras usando una espatula.

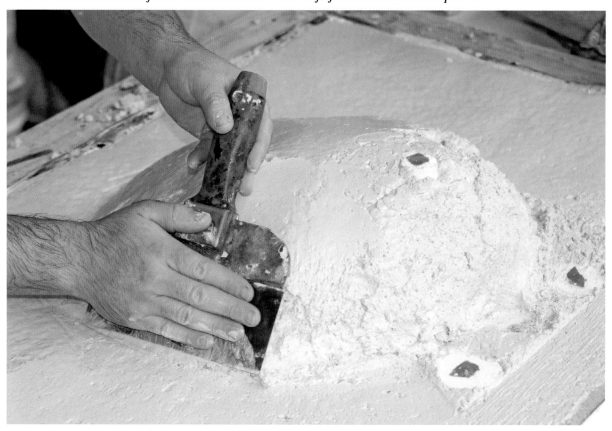

Continue smoothing the base of the sink. Gloves aren't imperative for working with wet concrete, says Doug Bannister, "However, it's hard on the skin. Young skin grows faster than old skin."

Continua alisar el base del lavabo. Los guantes no son necesarios cuando trabaja con concreto mojado, dice Doug Bannister, "Sin embargo, el concreto es muy duro en el piel. El piel joven crece mas rapido que el piel viejo."

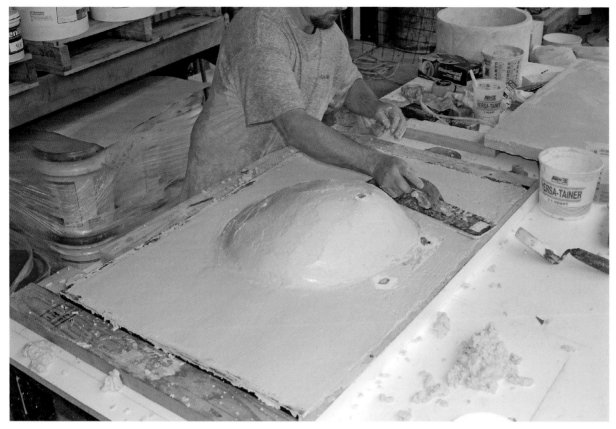

Put the final finishes on the base…

Pone los acabos finales en el base . . .

Make sure the knockouts are clear…

Asegura que los (knockouts) estan totalmente quitados . . .

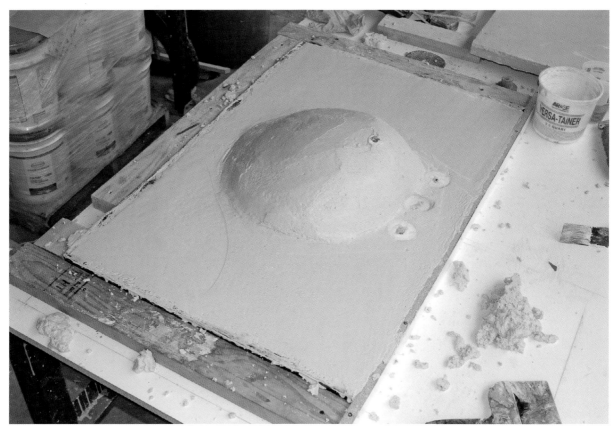

… and allow it to cure overnight. It is better to cover the piece with plastic to allow a more even cure.

. . . y permite curar por la noche. Es buena idea cubre con plastico para permite una curacion plano.

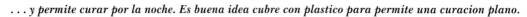

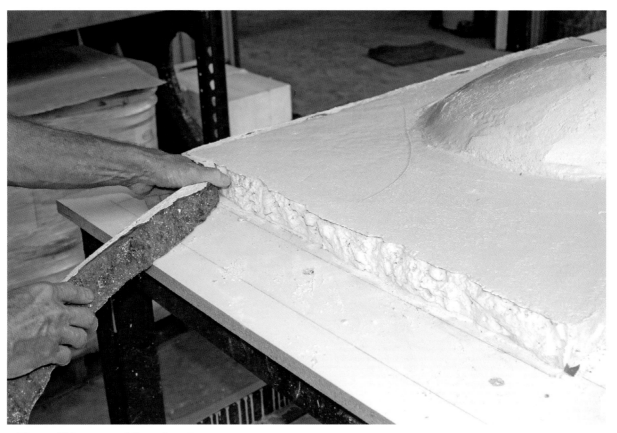

The mold is removed from the edges.

Quita el molde de los bordes.

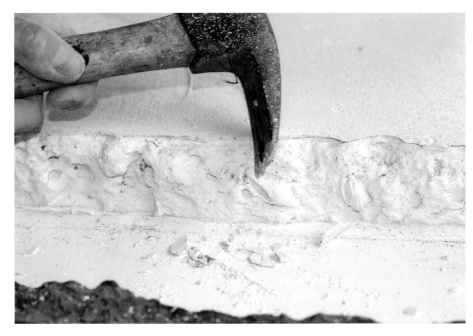

Rough edges are carefully corrected with a hammer…

Arregla los bordes asperos con un martillo . . .

… and painters 5-in-1 tool.

. . . y una herramienta para pintores.

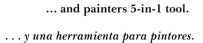

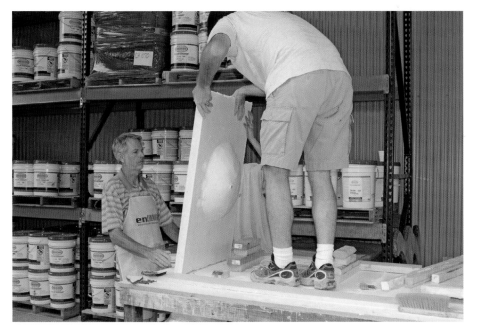

The counter is lifted off its base and laid on blocks to support it. The counter and sink will weigh about 200 pounds.

Se levanta el tablero del base y pone sobre los bloques para sostener.

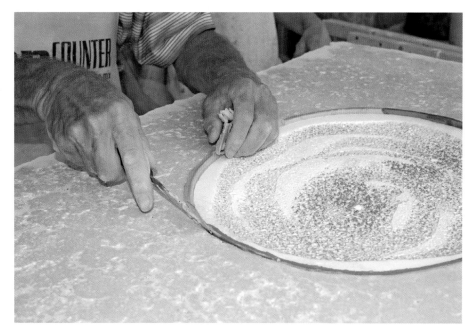

The modeling clay is removed with a putty knife and the sink mold is removed from the counter. We then add a little Xylene solvent to remove the modeling clay, and lightly clean with a wire brush.

Quita el arcillo de modelo con una espatula y quita el molde de lavabo del tablero. Anade un poco del solvente "Xylene" para quita el arcillo de modelo y limpia finamente con un cepillo de alambre.

We want to smooth the sink and counter surface at this point with a light grinding on the surface and inside the bowl.

Ahora, alisa el lavabo y superficie del tablero. Un pulvirizado fino sobre el superficie y la pila.

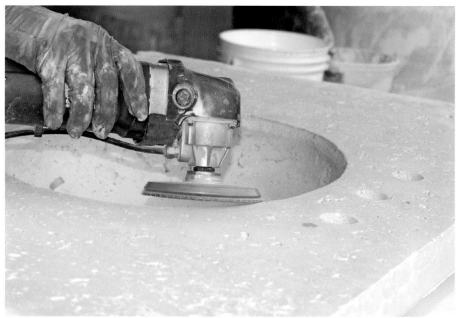

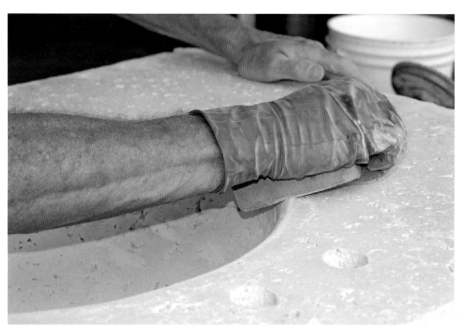

A light sanding smooths the sink edge and helps clear away any modeling clay that clung to the surface. Stamp Store SprayBase, Brickform SG, or Miracote Smooth can be spread inside the sink to get an even surface. Make sure that all the finishing work is completed before staining because you don't want to chip at it later.

Una pasada lijera de arena ensuavece las orillas del fregadero y ayuda a esclarecer cualquier projecto del modelaje que sostiene la superficie. La tienda de la estampa, la base del rocio, la forma del ladrillo, SG o Miracote ensuavisador puede ser extendido adentro del fregadero para obtener una superficie pareja. Asegurarse que el trabajo terminado esta completado antes de empezar a pulir. Porque ustedes no quieren descaraperarlo después.

We will apply a blue Sedona acid stain. Wear gloves and eye protection. The stain will be applied at full strength with a brush.

Aplica un tinte azul "Sedona" de acido. Lleva los guantes y proteccion de ojos. Aplica el tinte al maximo fuerte con un cepillo.

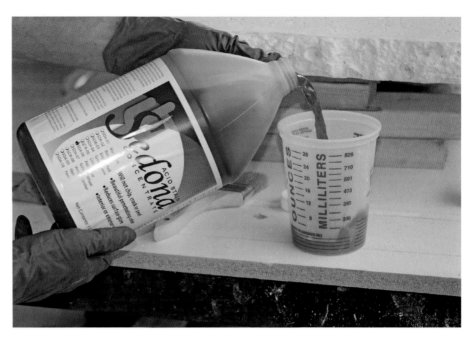

Apply the stain to the edges first to avoid drips that become difficult to disguise.

Primero, aplica el tinte a los bordes para evitar las gotas que no puede disfrazar.

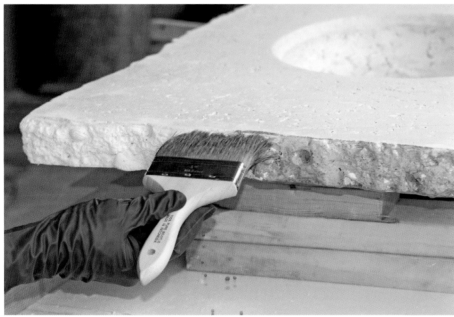

Apply stain to the top surface using circular strokes.

Aplica el tinte al superficie del parte de arriba, usando pinceladas circulares.

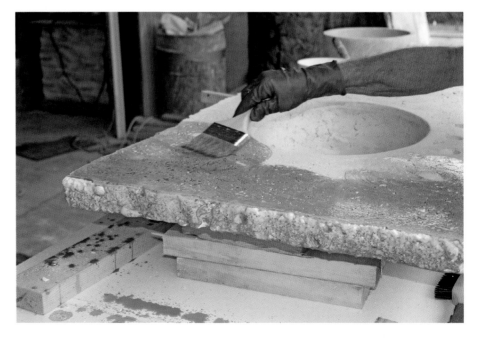

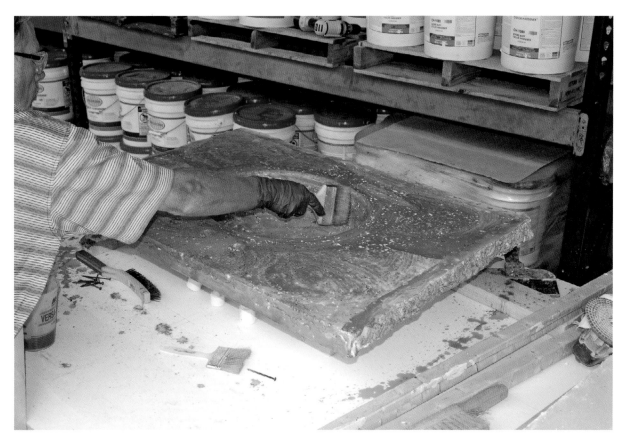

After coating all the surfaces, allow the stain to sit for approximately twenty minutes. The longer the stain is on the concrete the deeper the color will be.

Despues de cubrir todos los superficies, permite quedar el tinte por aproximamente veinte minutos. Mas tiempo que queda, lo mas fuerte sera el color.

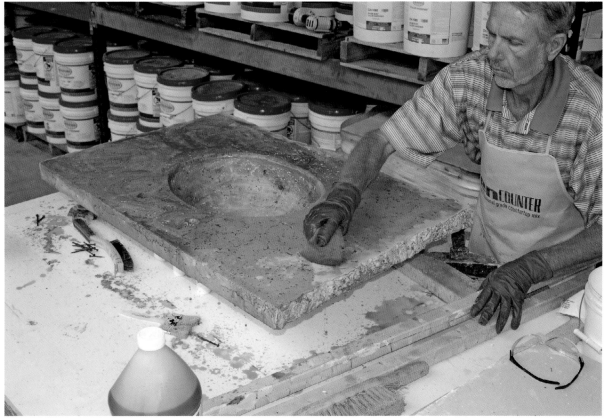

Remove the stain with water and sponge. If you are working outside, you can simply hose the stain off.

Quita el tinte con agua y una esponja. Si trabaja afuera, pueda usar la manguera para quitar el tinte.

A high-gloss sealer is added to stained counter. This will act as a release when the voids are filled.

Anade Un tinte de alto lustre al tablero tinteado. Puede ser un escape cuando llenar los vacios.

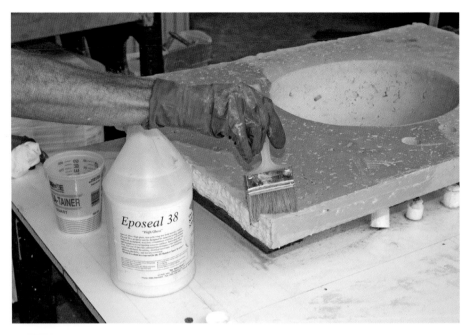

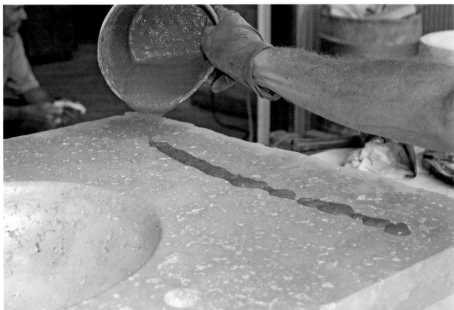

Grey EnMAGIC is mixed with water to create a slurry that will be used to infill the voids.

Mexcla EnMAGIC color gris con agua para crear un capa que usar para llenar los vacios.

A rubber float is used to work it into the voids…

Usa una flota de goma para llenar los vacios . . .

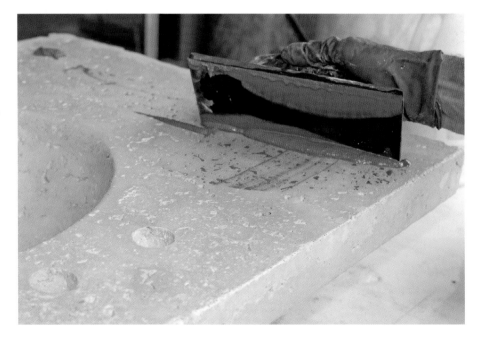

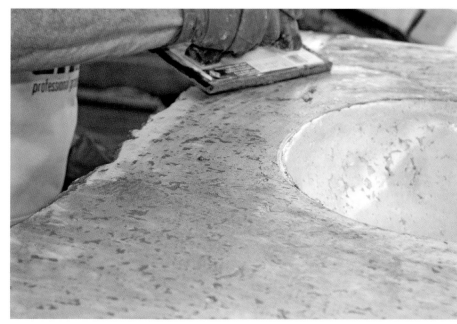

... like so.

. . . como asi.

A rubber spatula can be used to work the sink area.

Puede usar una espatula de goma en area del lavabo.

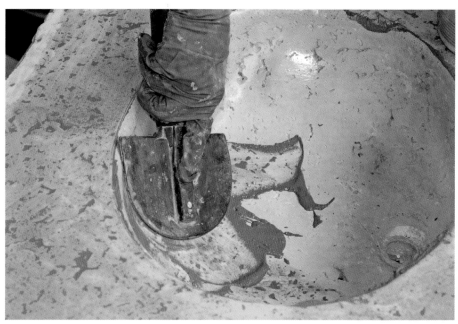

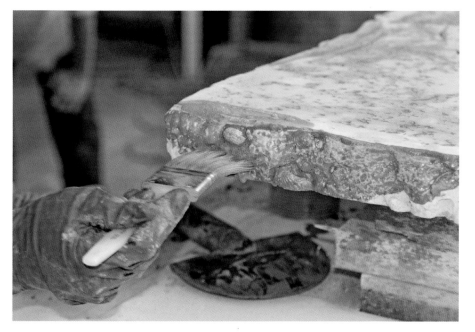

Use a brush to work the grout into the edge to create uniform color variation.

Usa un cepillo para llenar la lechada al borde y crear un variacion de color uniforme.

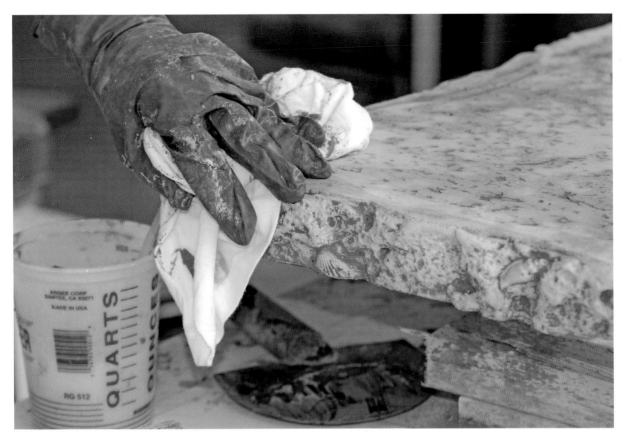

Remove excess with a clean, soft cloth.

Quita el exceso con una tela suave y limpia.

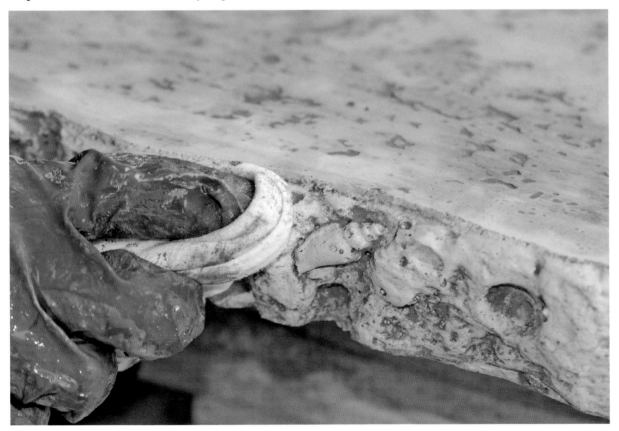

Pay special attention to revealing highlights in the edge mold. Then allow the grout to set for about fifteen minutes.

Da la atencion a mostrar los toques de luz del molde del borde. Permite la lechada (set) por mas o menos 15 minutos.

A new, lighter colored grout is mixed.

Mexcla una lechada nueva y mas clara.

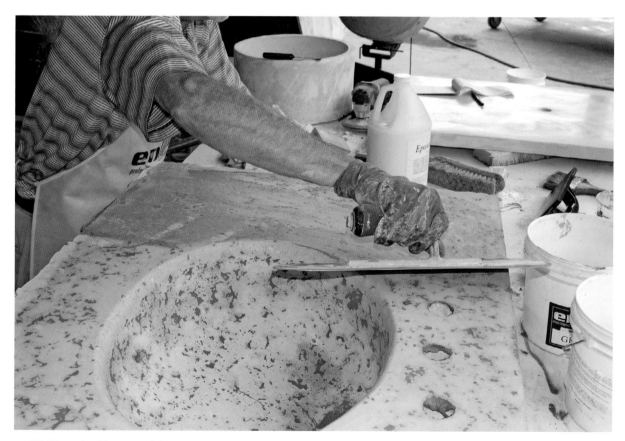

We'll apply this coat with a metal trowel.

Aplica la capa con una llana de metal.

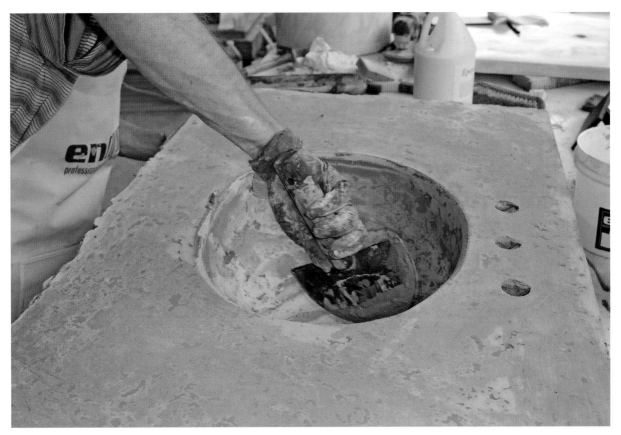

The circular spatula comes in handy again around the sink, a brush on the edges. The counter will now be allowed to cure for a couple of hours.

El espatula circular es muy util, otra vez, alrededor de el lavabo, un cepillo a los bordes. Deje curar el tablero por unos horas.

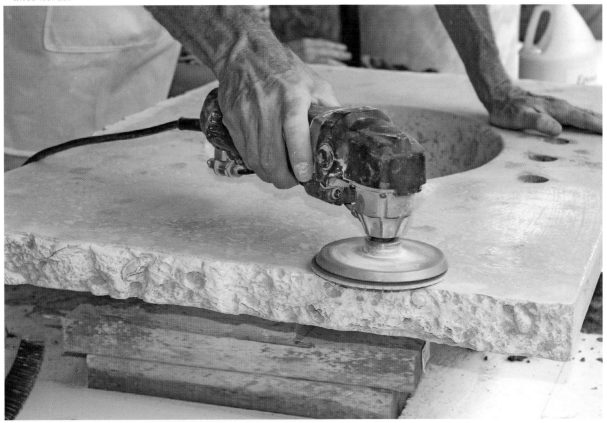

Smooth the counter surface with a light, dry sanding.

Alisa el superficie del tablero con una lijando fino y seco.

Sand inside the sink by hand.

Lija adentro del lavabo a mano.

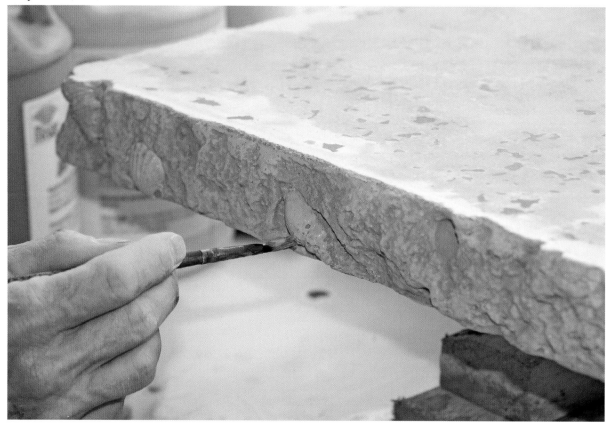

A small brush is used to apply an opalescent rainbow stain to the shell forms on the sink edge, making them stand out just a little bit more.

Aplica un tinte el color arco iris y opalescente con un cepillo pequeno a las formas de la concha en el borde del lavabo, para que resaltar un poco mas.

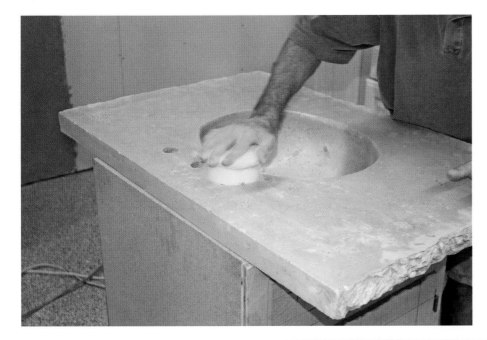

After cleaning away any dust or debris, a beeswax finish is applied to the countertop...

Despues de limpiar algun polvo y tirar alguna basura, aplica una acaba de cera de abejas al tablero . . .

... And buffed to a shine.

...y pule hasta que brilla.

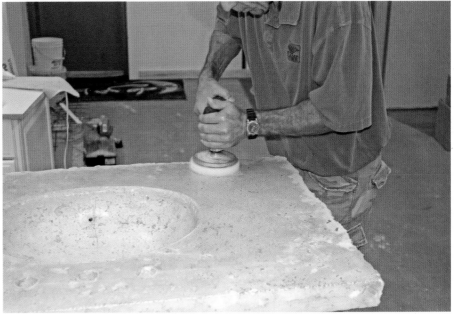

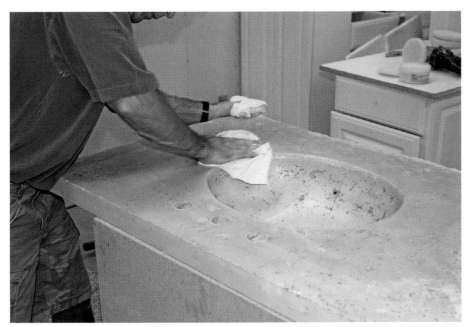

A final buff with a soft, clean cloth and this countertop is ready to go.

Un pulido final con una tela suave y limpia y este tablero esta listo.

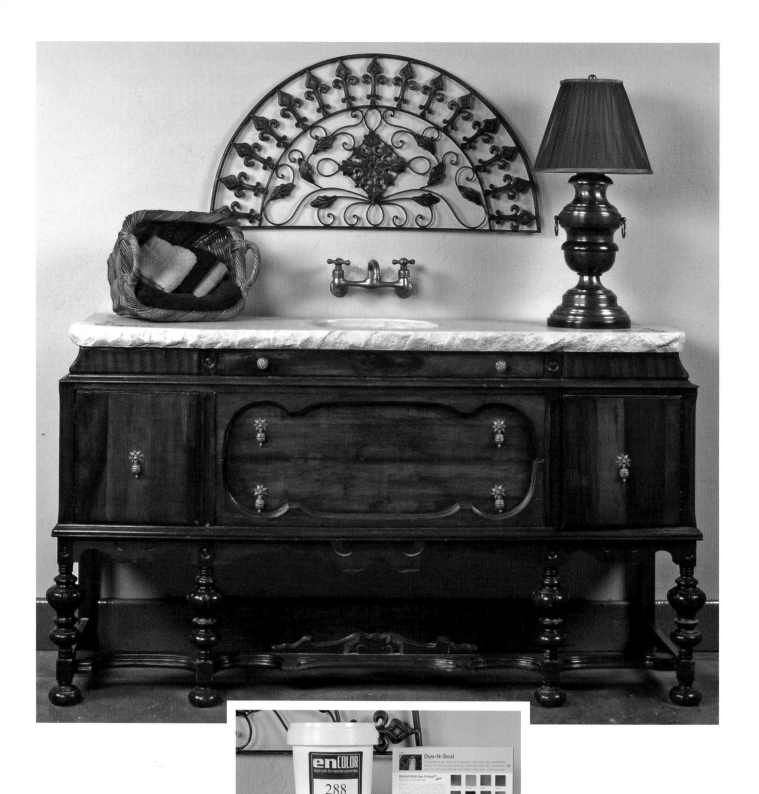

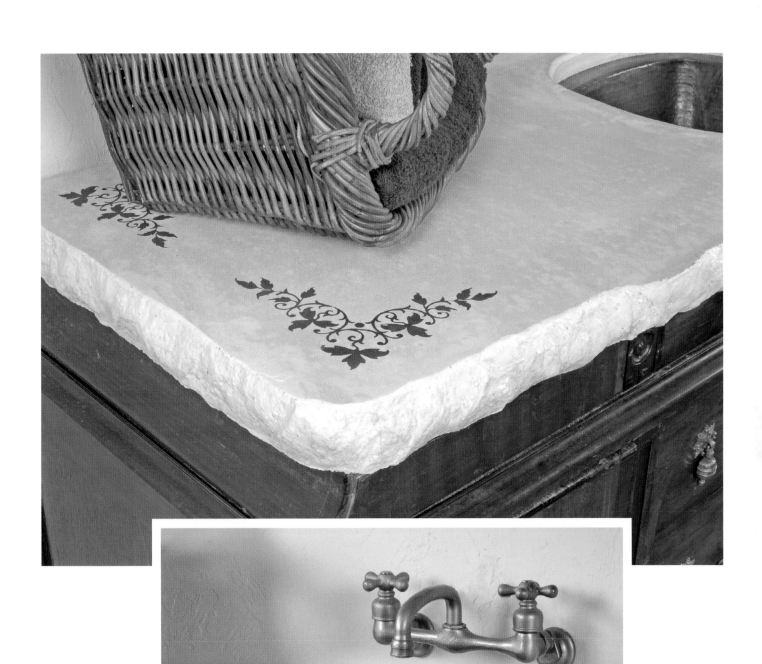

Part 4
Cast-in-Place, Monolithic Counter for Long Vanity

Parte 4
Un tablero monolitico y moldeado en lugar por un tocador largo

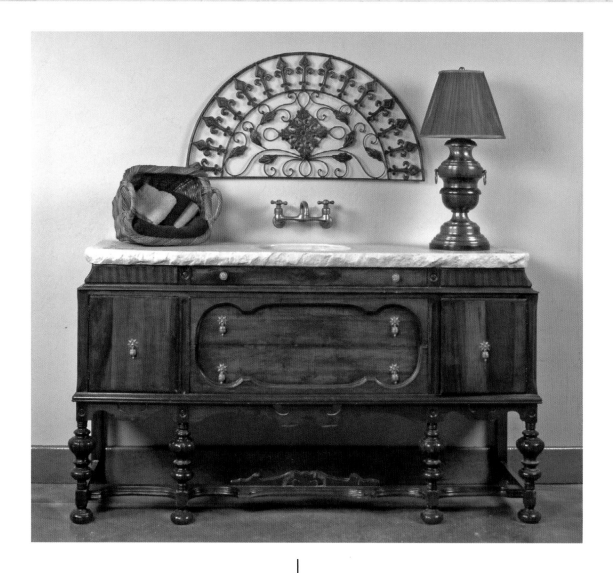

For this project, we start with a wonderful old buffet found in an antique store. The top was first carefully removed from the base, and then a mold constructed on top for a cast-in-place vanity with an undermount, hammered copper sink. We'll take a shortcut, and cast this countertop right on top of that undermount sink.

Polishing goes fast if you use tools that cost thousands of dollars, or takes forever if you use small sanders or elbow grease. To keep this project affordable and attainable, we're going to use finishing products that achieve incredible results without the cost, dust, and hours of labor. Wall-mount plumbing will complete this enviable powder room addition.

Por este proyecto, empezamos con un aparador maravillos y viejo, que encontremos en una tienda de antiguedades. Separa el parte de arriba del base, y despues construye un molde encima por un tocador moldeado en lugar con un lavabo de cobre martillado pegado debajo. Para hacer mas rapido, vamos a moldear este tablero encima del lavabo pegado debajo.

Encerando tarde poco cuando usa las herramientas que cuesta miles de dolares o tarde mucho cuando usa lijadores pequenas o energia fisica. Para mantener este proyecto bastante barato y uno que puede hacer bastante facilmente, vamos a usar los productos de acabar que tiene exito sin la cuesta, polvo y horas de trabajo. (Wall mount plumbing) va a terminar este adicion de servicios de banito.

A base for the mold was formed with 2 x 2 boards. A piece of 3/4-inch melamine was cut to fit the top, and given a beveled edge. The sink form from the hammed copper sink was used to create and cut out the drop-in hole in the center.

Forma un base por el molde con talbas de 2 x 2. Corta una pieza de melamina de 3/4 pulgadas para la parte de arriba. Pone un borde biselado a esta pieza. Usa la forma del lavabo de cobre martillado para crear y cortar el hueco pasado por el centro.

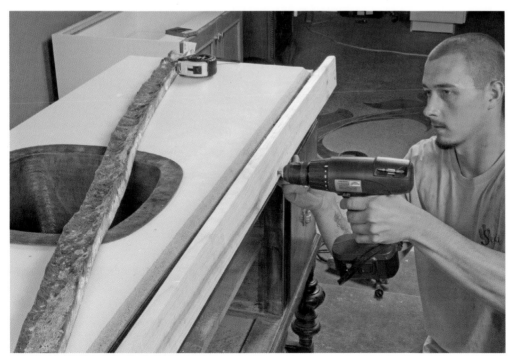

A backboard for the self-releasing edge treatment enFORM rubber molds is created out of one 1 x 4 in front...

Crea una tabla de refuerzo por los moldes de goma de enFORM que tiene bordes del tratamientos (self-releasing) con uno 1 x 4 en el frente . . .

... and one on each side.

. . . y uno a cado lado.

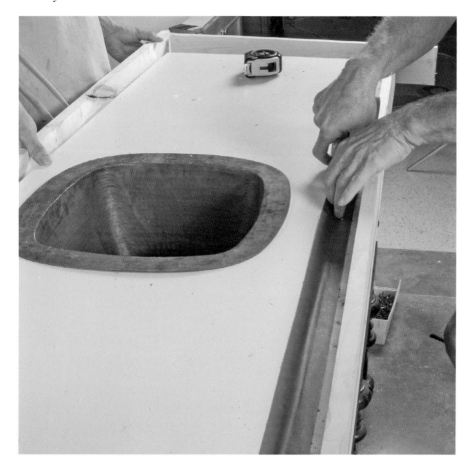

Tape is applied to protect the cabinet surface from leakage. It is important to have the floor surface protected prior to a pour, too.

Aplica cinta a proteger de salida, el superficie del armario. Es importante proteger el suelo tambien, antes del diluvio.

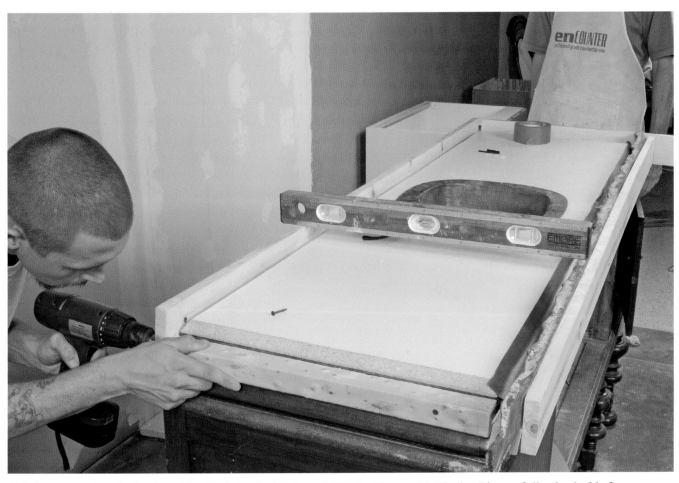

It is important that the back mold wall sit level with the enFORM rubber mold. The level is carefully checked before securing the back wall mold.

Es importante que el pared de atras del molde esta nivel con el molde de goma enFORM. Examina el nivel cuidadosamente antes de asegurar el molde del pared de atras.

Reinforcement wire is cut prior to the pour, and the sink knock-out prepared.

Corte el alambre de armazon antes del diluvio, y prepara el (knockout) del lavabo.

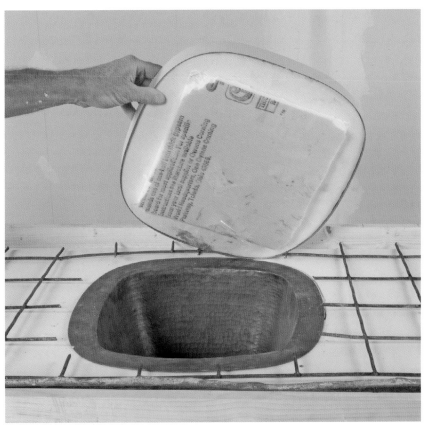

This pink sink plug is 1 ¼-inch deep on top to match the thickness of the final countertop, plus a ¾-inch drop to fit securely in the sink base. This smaller surface area will lock the mold securely in the sink so that it will not shift during the pour.

Este tapon rosado del lavabo es 1 1/4 pulgadas de profundidad al parte de arriba para corresoponder al grosor del tablero final, mas un espacio de 3/4 pulgadas para que el base del lavabo quepa con seguridad. Este area mas pequeno de superficie va a cerrar el molde con seguridad para que no mueve durante del diluvio.

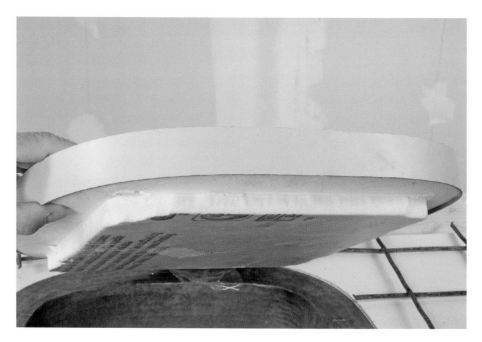

After cutting the shape of the sink drop in from Styrofoam, a 1 1/4-inch strip laminate was glued to the mold with liquid nails and taped with clear box tape until it dried. A close-up reveals the seam of the laminate strip.

Despues de cortar la forma del molde de lavabo en stirofoma, una tira de laminado de tamano 1 1/4 puldadas estaba pegado al molde con clavos liquidos y pegado con cinta transparente hasta que seca. Una foto cercana muestra la junta de la tira de laminado.

The enFORM rubber mold is secured to the front and side mold walls with screws.

Asegura el molde de goma de enFORM a las paredes del frente y los lados con los tornillos.

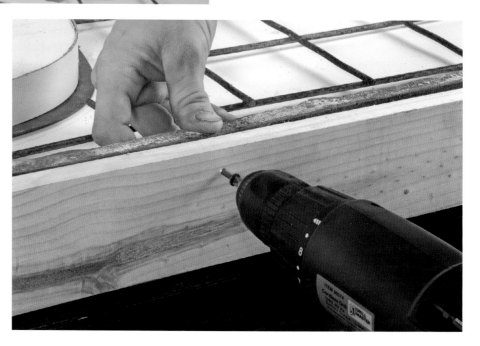

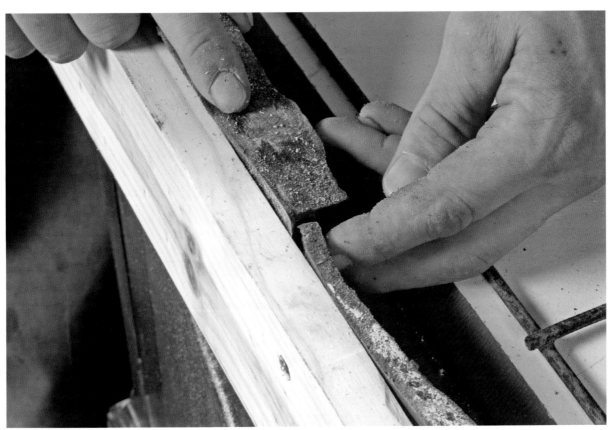

This overlap of two mold pieces will be easily remedied after the pour simply by knocking the edge off with a hammer.

Arregla este parte superpuesta de dos piezas del moldes despues del diluvio por quitar el borde con un martillo.

Reinforcement wire is tacked to the base of the mold. There is still enough play that concrete will get underneath. This will prevent the wire from rising.

Pega un alambre de armazon al base de la forma. Todavia hay bastante espacio para que el concreto pude va debajo. Este prohibe el alambre de levantar

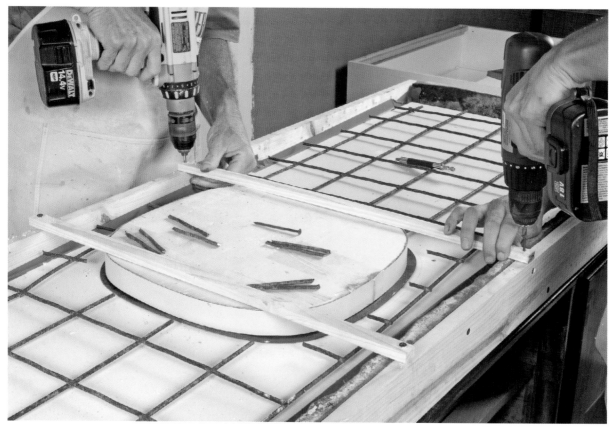

Float supports for the sink mold are added for extra assurance that the mold will stay in place during the pour. On top of the sink mold, four-inch pieces of concrete wire were snipped and will be placed during the pour to prevent cracking around the sink corners.

Anade soportes de flota por moldes des lavabos para mas seguridad que el molde no mueve durante del diluvio. En el parte de arriba del molde de lavabo, Unas piezas del alambre de concreto de tamano de cuatro pulgadas, estaban cortados y pondre durante del diluvio para prohibir rjando en las esquinas del lavabo.

Plastic sheeting is spread out to protect the floor.

Cubre un cobertor plastico sobre el suelo para protegerlo.

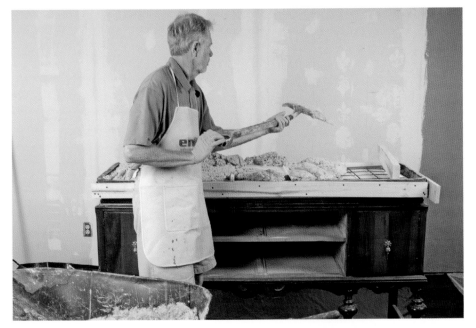

Concrete is mixed and added to mold.

Mexcla el concreto y anade al molde.

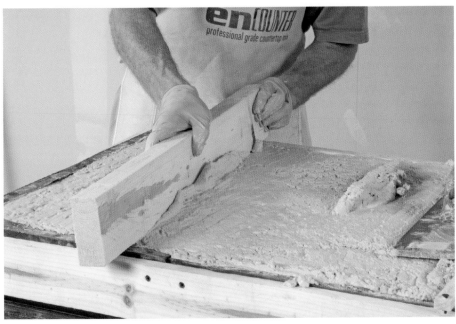

A 2 x 4 is used for an initial screed of the surface.

Usa un 2 x 4 por un superficie (screed) inicial.

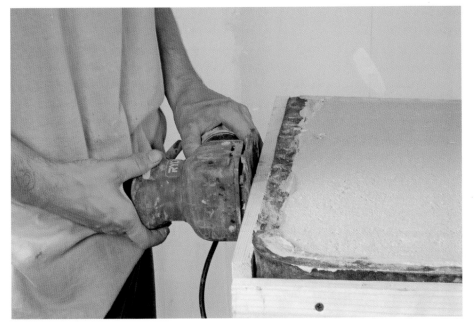

A vibrator is used against the mold walls to work the concrete into place and fill all the air pockets.

Usa un vibrador contra las paredes del molde para llenar el concreto en los bosillos del aire.

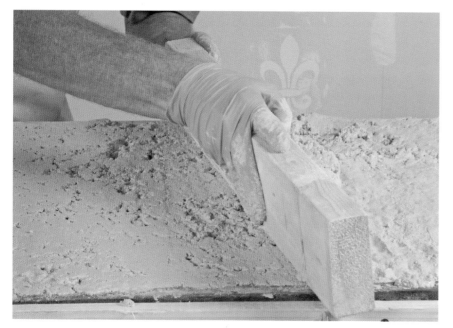

Another pass with the 2 x 4 screed.

Otra pasa con el 2 x 4 (screed).

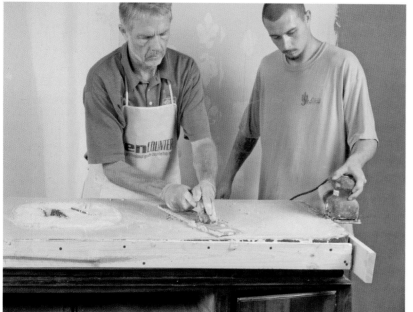

Using trowel and vibrator, we continue to work the surface, making sure that the surface is level.

Usando la llana y un vibrador, continuamos trabajar el superficie, aseguramos que el superficie es nivel.

A float helps to create a clean line around the sink form.

Usa una llan para una linia limpia alrededor de la forma del lavabo.

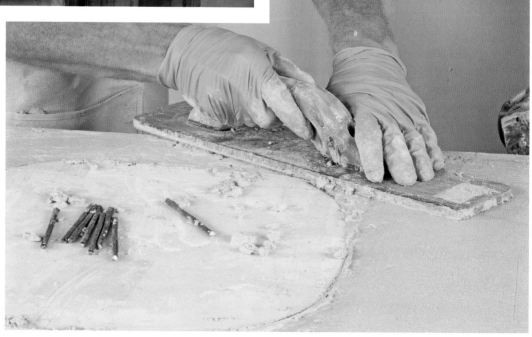

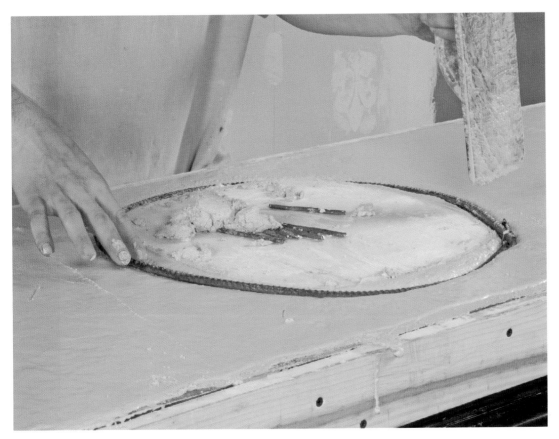

A ring of 3/8 or #3 steel reinforcement rod was bent to encircle sink and reinforce the weakest area of the countertop. It is now embedded carefully in place.

Un anillos de 3/8 or #3 barra de armazon de acero estaba doblado para circundar el lavabo y reforzar el area mas debil del tablero. Ahora esta implantado cuidadosamente en lugar.

The reinforcement rod is sunk with gentle tapping, making sure it is ¼ inch below the counter-top surface. The corner reinforcement rods are embedded in the same way.

La barra de armazon esta implantado con golpeados suaves, asegurando que es un 1/4 pulgada debajo del superficie del tablero. Las barras de armazon de las esquinas estan implantado del mismo modo.

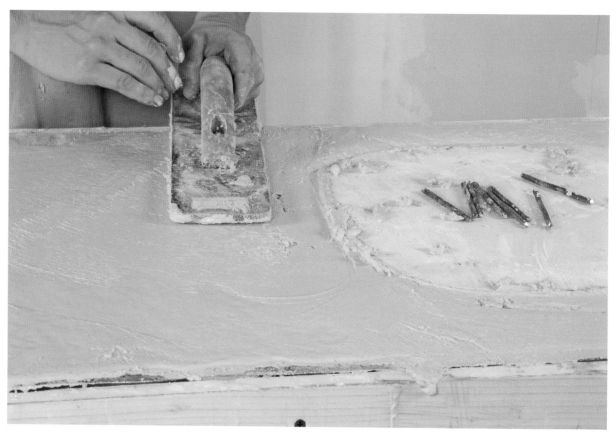

Don't overwork the surface.

No abusa el superficie.

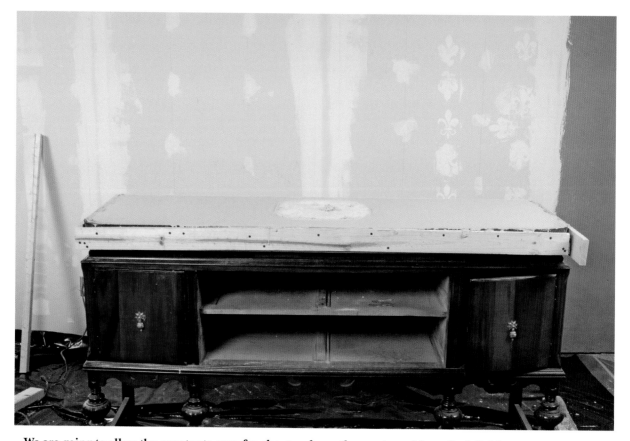

We are going to allow the counter to cure for about an hour, then re-trowel for a final finish.

Vamos a dejar curar el tablero por mas o menos una hora, entonces extende la llana otra vez por un acabado final.

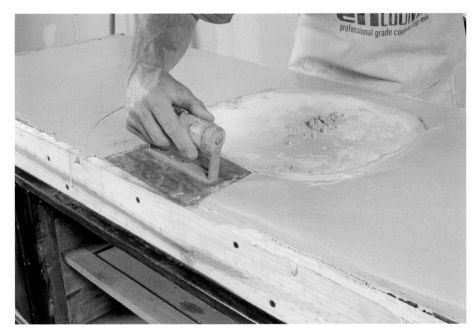

After the concrete has had a chance to set up, we return for the final fussing. Here an edge trowel is used to create a nice lip around the top of the sink.

Despues de curar, regresamos para el acabado final. Aqui usa una llana del borde para crear un buen labio alrededor del parte de arriba del lavabo.

The surface is worked gently for its final finish.

Extende la llana suavamente por un acabado final.

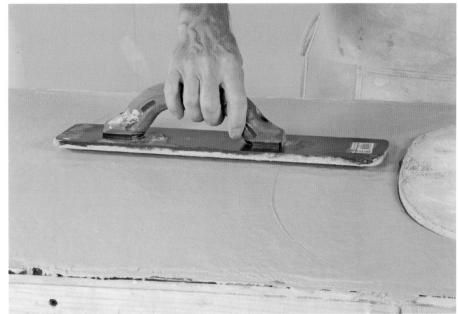

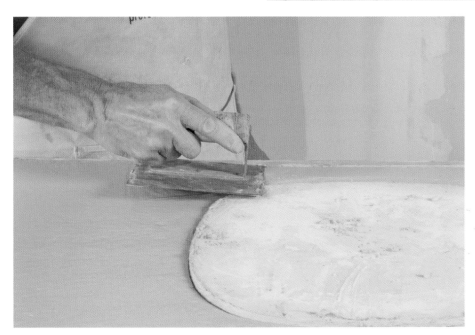

The sink edge is carefully cut and smoothed.

Corta y alisa, cuidadosamente, el borde del llavabo.

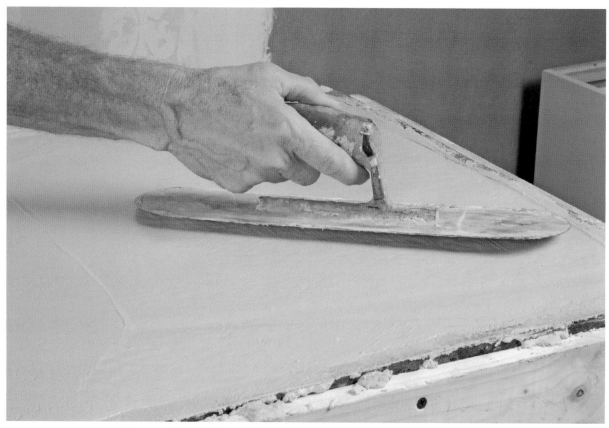

Extra attention is given to the edges to ensure their appeal after de-molding. The countertop is covered with 1 mil poly, then allowed to cure overnight.

Da atencion extra a los bordes para asegura que se ve bonito despues de quita el molde. Cubre el tablero con poly de 1 mil, y deja curar por la noche.

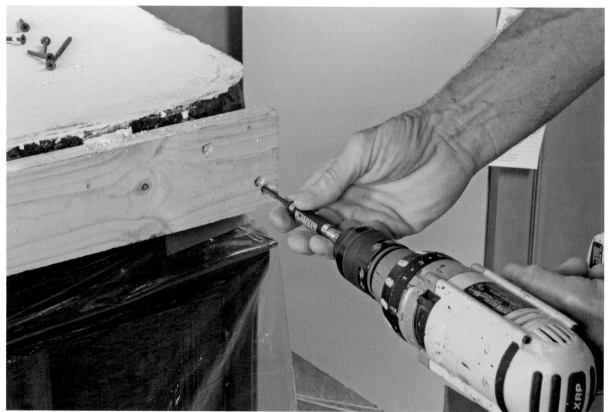

After curing overnight, the 2 x 4 mold edges are removed.

Despues de curacion por la noche, quita los bordes del tamano 2 x 4 del molde.

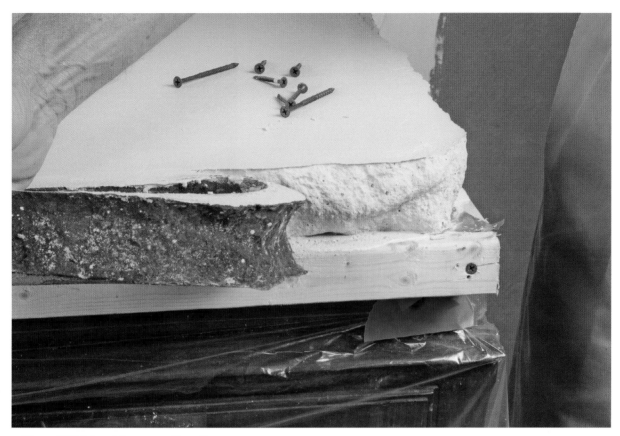

The enFORM mold comes off easily.

El molde enFORM quita muy facilmente.

Here is one of the rough edges caused by enFORM overlap.

Aqui hay uno de los bordes asperos a causa el parte superpuesta.

It is easily remedied using a simple tool.

Arregla facilmente con una herrameinta sencilla

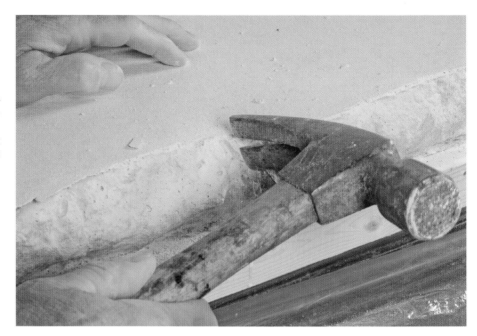

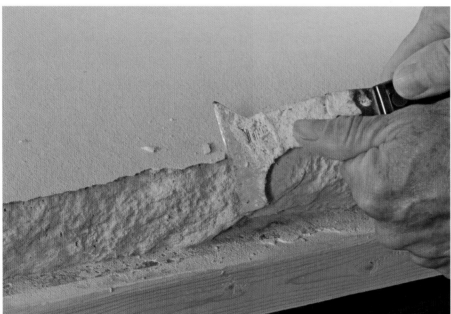

A 5-in-one painter's tool is put to work perfecting the edge. Remember, we don't want it too perfect.

Usa una herramienta de pintores para perfectar el borde. Recuerda que no queremos demasiado perfecto.

A box knife can be used to cut away the masking tape.

Corta la cinta de enmascarar con un cuchillo de caja.

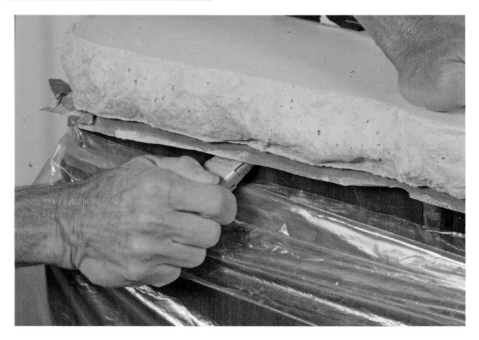

The area is recovered with masking tape and plastic sheeting to protect the furniture during the finishing process.

Cubre el area con cinta de enmascarar y cobertor plastico para proteger los muebles durante del proceso del acabar.

Continue to use the 5-in-1 painter's tool used to release sink.

Continua usar la herramienta de pintores para quitar el lavabo.

We remove the sink mold by creating a hole through the knock-out and then pulling it loose.

Quita el molde del lavabo, por crear un hueco en el (knockout), y despues tirarlo.

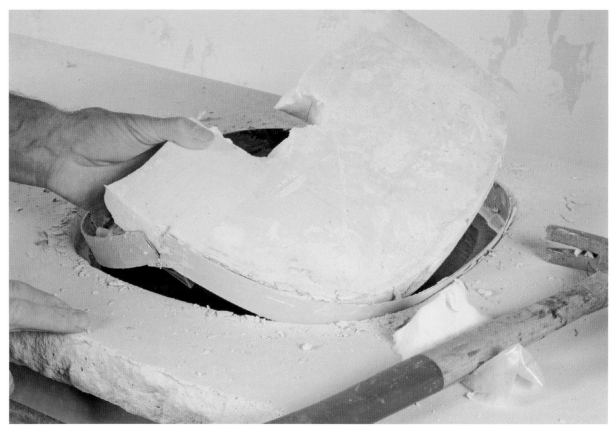

This mold broke in half, facilitating its release.

Este molde se rompio a la mitad, y despues fue mas facil a quitar.

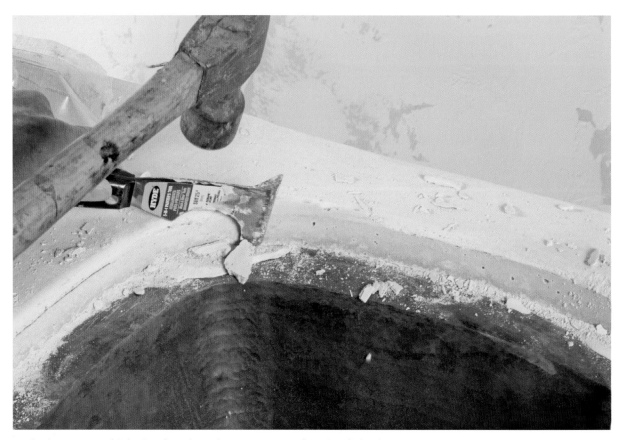

The hammer and 5-in-1 painter's tool team up to perfect the sink edge area.

Un martillos y una herramienta de pintores, los dos, estan utiles para perfectar el area del borde del lavabo.

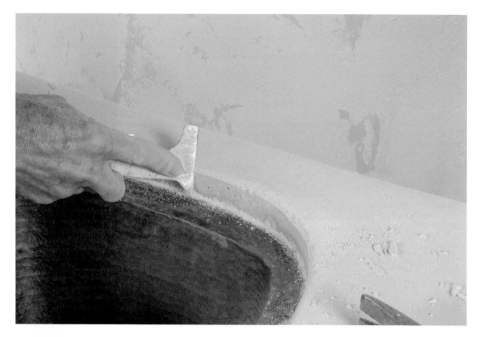

Great care is used in removing concrete overlap so as not to damage the sink.

Ten cuidado a quitar el parte superpuesta de concreto para que no hace dano al lavabo

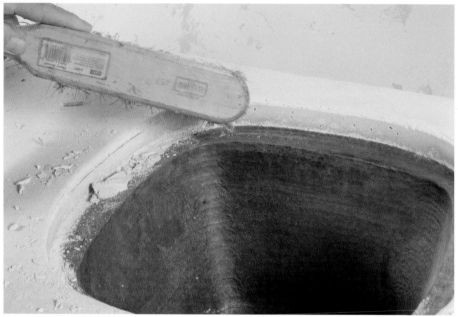

The surface takes shape over the drop-in sink.

Se ve el superficie sobre el lavabo pasado.

A 100-grit single head polisher is used to lightly treat the top and give it a nice, soft look.

Us un lijador de 100 grano para lija suavamente el parte de arriba y darlo un acabado bueno y suave.

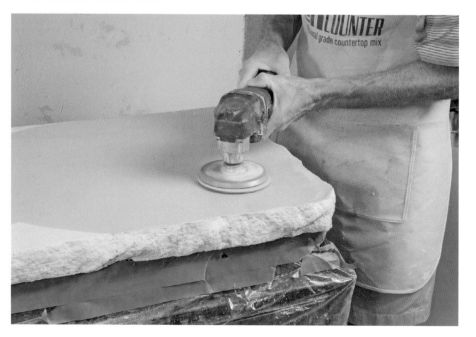

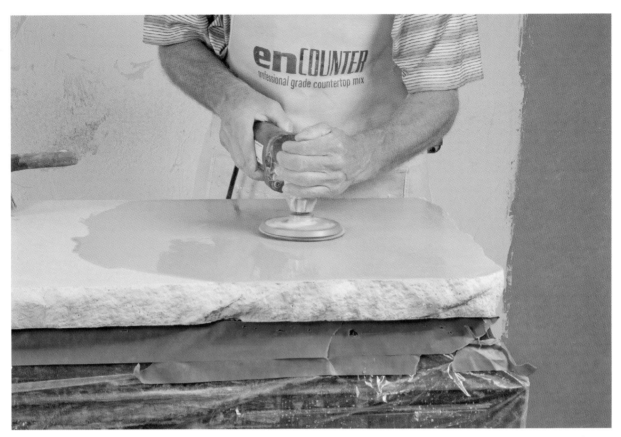

The surface is wet in order to help preserve the sander and add to the abrasion. You can use a less expansive sander, or even a hand sand.

El superficie esta mojado para mantiene el lijador y anade abrasion. Puede usar un lijador mas barato o lija a mano.

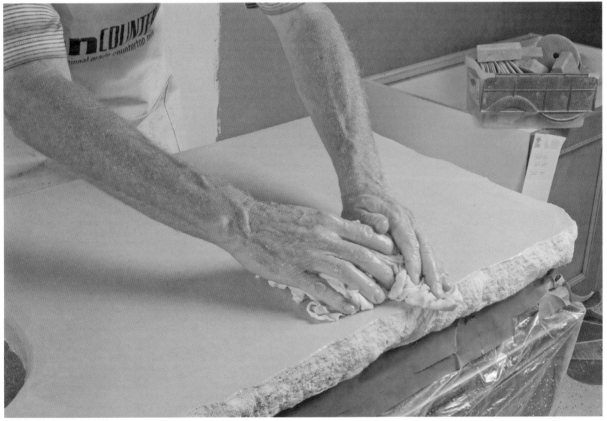

A brush is used to apply the water.

Aplica el agua con un cepillo.

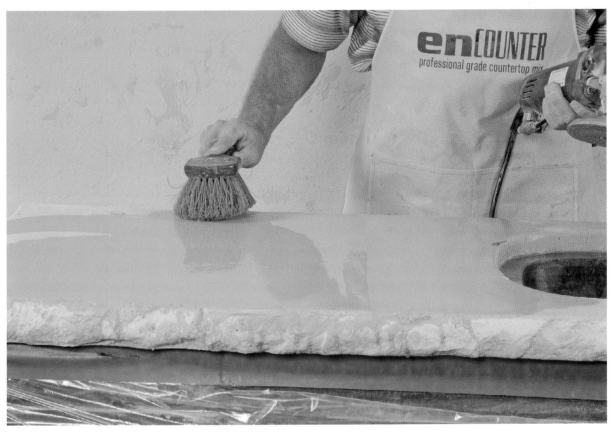

A soft wet cloth is used to clean the surface.

Usa una tela suave y mojada para limpiar el superficie.

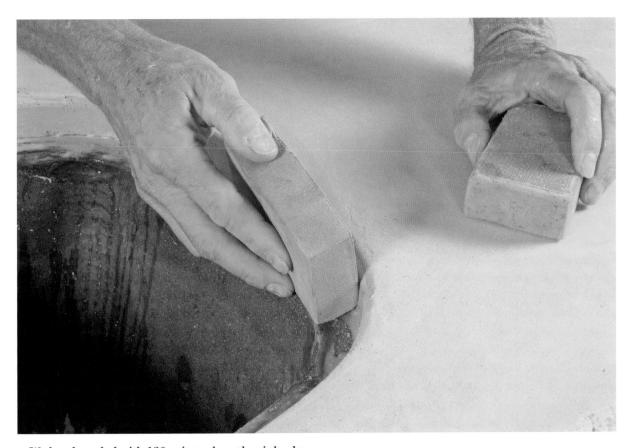

We hand sanded with 120-grit to clean the sink edge.

Lija a mano con papel del grano 100 para limpiar el borde del lavabo.

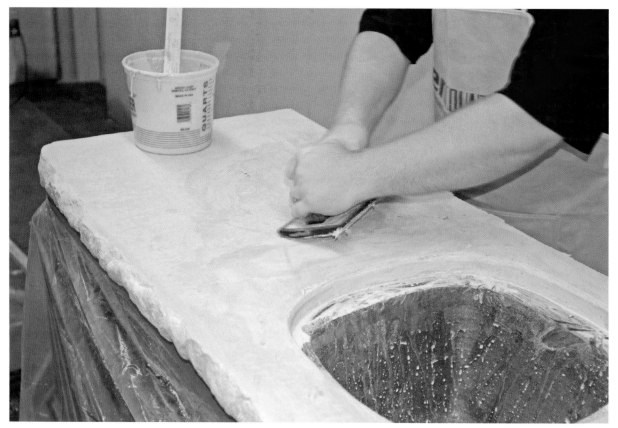

EnMAGIC slurry is trowelled across the surface to smooth it.

Extende la llana con una capa de enMAGIC sobre el superficie para alisarlo.

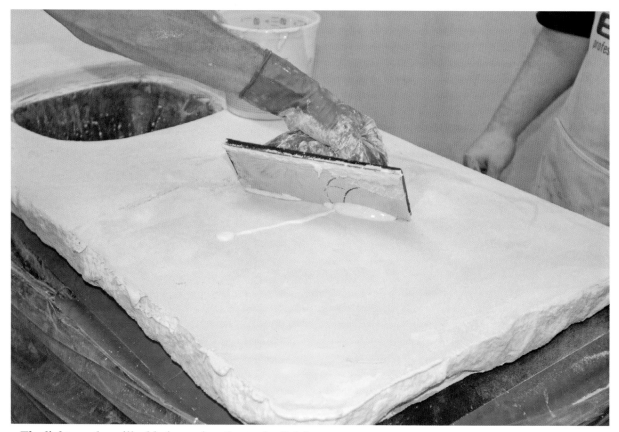

The lighter color will add nice variegation to the finish.

El color mas claro anade una variacion buena al acabado.

Stencils are carefully placed at even points from the four corners of the vanity countertop and taped in place.

Pone los estarcidos cuidadosamente a puntos del mismo distancia de las esquinas del tablero de tocador y pegalos en lugar.

The stencil is then pulled back and the paper removed to reveal the sticky side.

Quita el estarcido y despues el papel para mostrar el lado pegajoso.

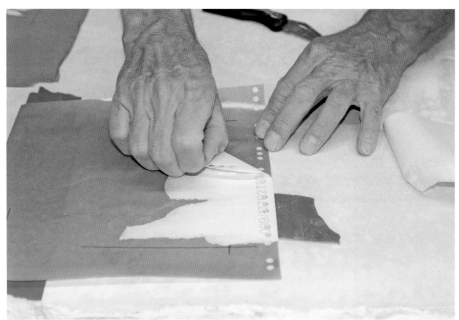

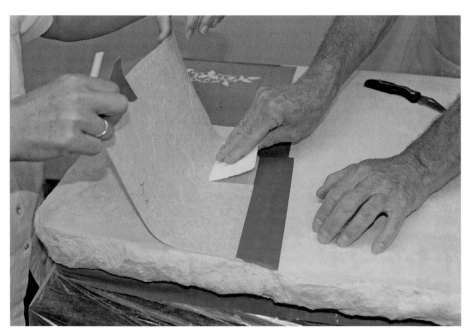

A plastic spatula is used to remove any air bubbles as the stencil is slowly lowered back into place on the countertop.

Usa una espatula de plastico para quitar algunas burbujas y luego regresa el estarcido en lugar sobre el tablero.

The top paper is carefully removed...

Quita el papel del parte de arriba cuidadosamente . . .

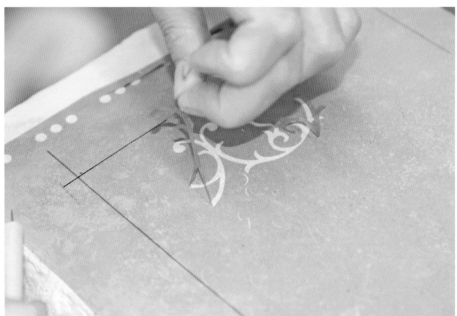

... and the stencils are carefully removed.

. . . y quita los estarcidos cuidadosamente.

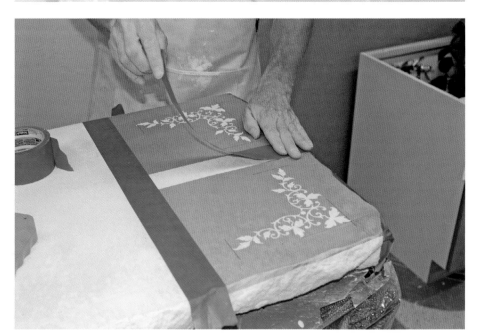

Other areas of the countertop are carefully masked with tape...

Pone la cinta cuidadosamente sobre otros areas del tablero. . .

... and paper.

. . . y papel.

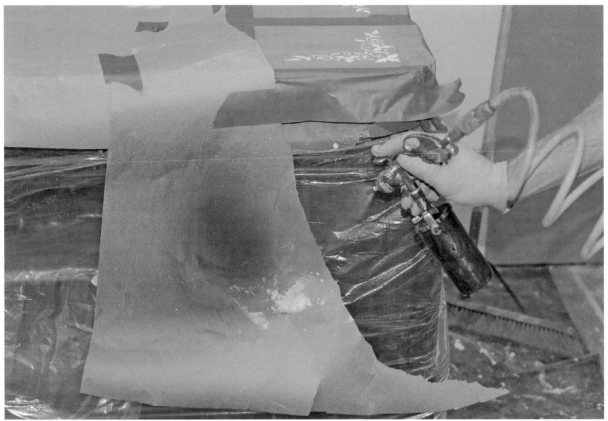

The entire piece is skirted in plastic sheeting and the edge is protected with masking tape.

Cubre la pieza entera con cobertor plastico y protégé el borde con cinta de enmascarar.

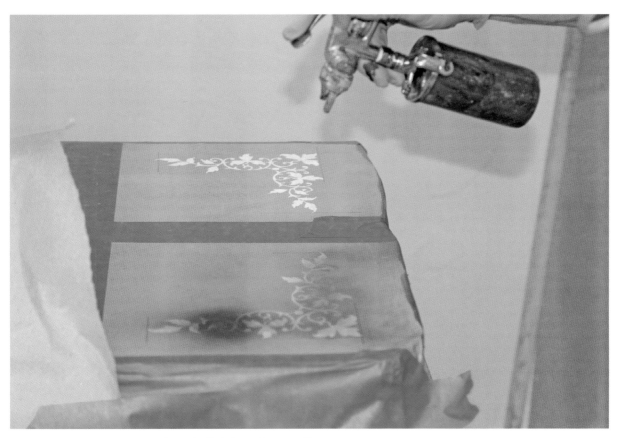

A spray gun is used to apply stain lightly to the stencil.

Usa una pistola para pulvirizar para aplicar el tinte, muy finamente, al estarcido.

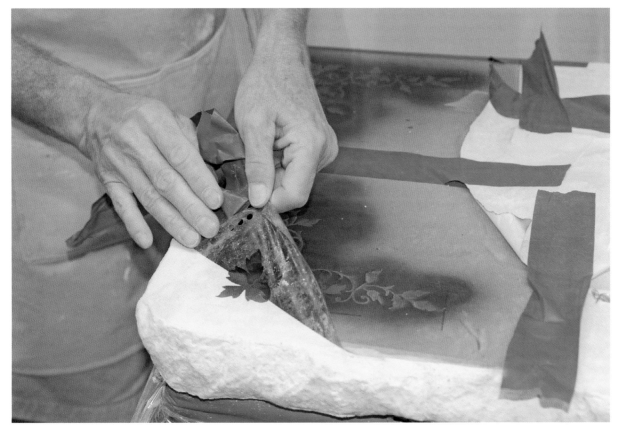

After curing, the stencil is removed.

Despues de la curaction, quita el estarcido.

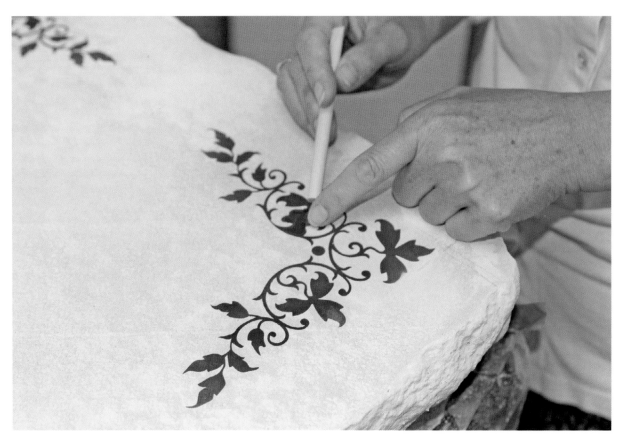

Any bleeds or areas where the stain ran under the stencil can be carefully chipped away with a pick or knife.

Usa un cuchillo para quitar algunos areas donde el tinte esta debajo del estarcido.

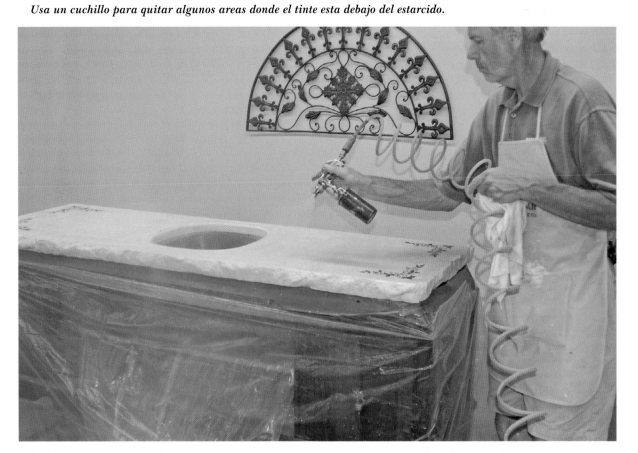

A light stain is then applied over the entire surface to create a more natural, multi-tone effect.

Aplica un tinte claro sobre el superficie total para crear un efecto de muchos tonos.

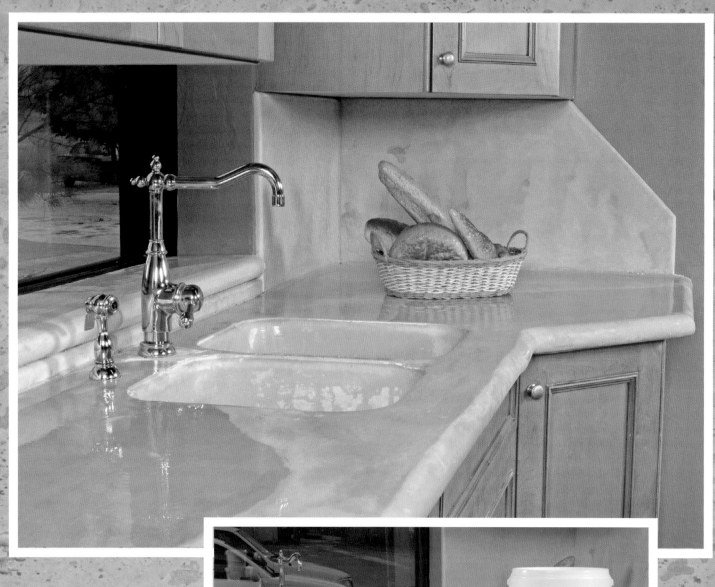
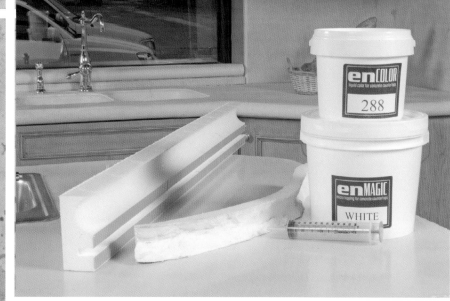

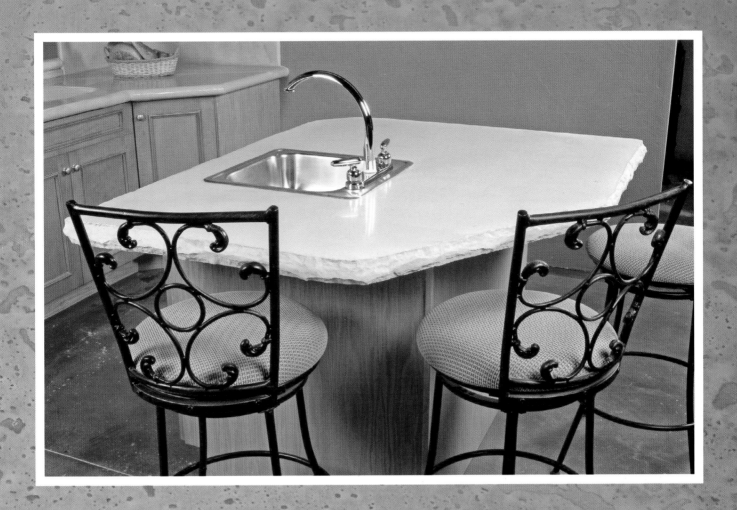

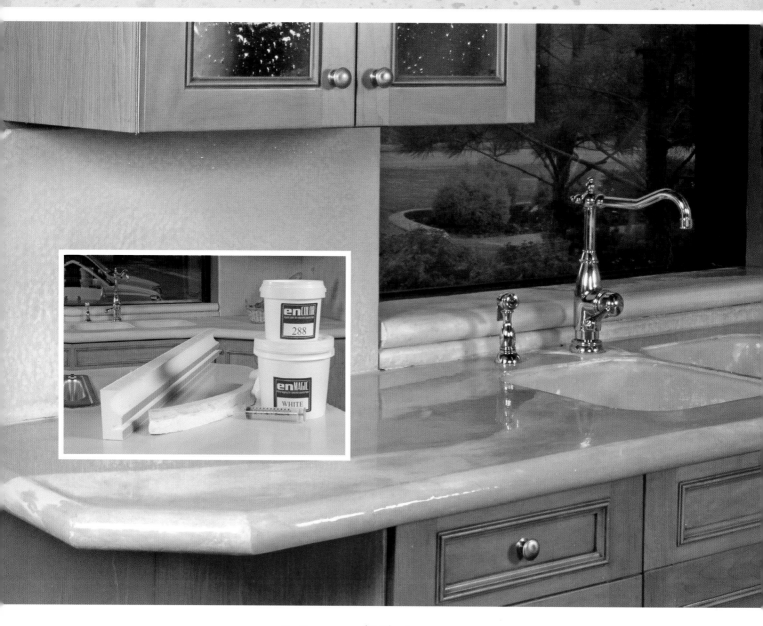

Monolithic
Kitchen Counter

By "monolithic" we refer to the fact that this sink and countertop are all one piece. This kitchen counter was cast-in-place using a rounded edge form and a custom double sink mold. We experimented with a prototype double sink and an elaborate wood form to hold the sink mold in place during casting. The result is a truly gorgeous, one-piece kitchen counter that measures 9 feet from end to end. We also cast matching custom tile pieces to fit the windowsill and backsplash, and the project coordinates with one of our other projects, the island counter.

Parte 5

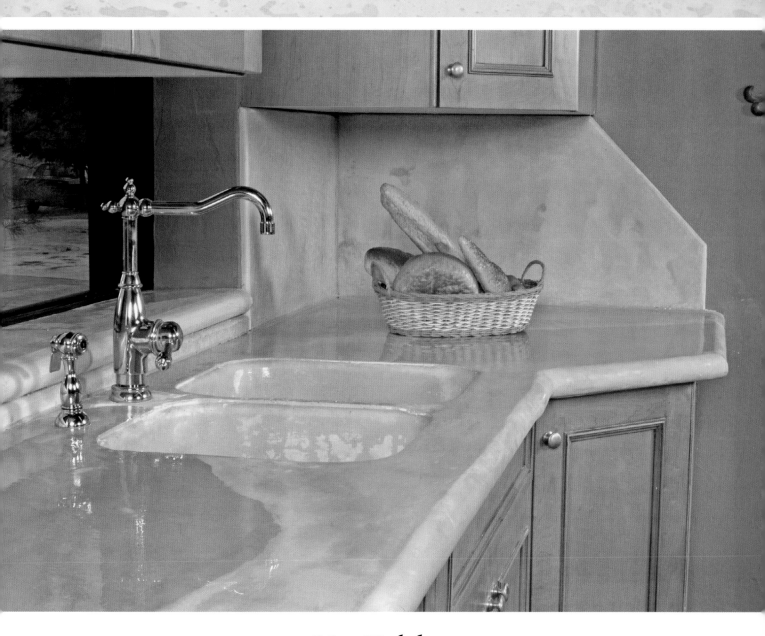

Un Tablero
de La Cocina Monolitico

La palabra monolitico quiere decir que el fregedero y tablero son juntos-una pieza. Este tablero, moldeado en lugar, usando una forma del borde rodundo, y molde del fregedero fabricado el gusto del comprador. Experimentabamos con un prototipo del fregedero doble y una forma de madera muy intricado para mantener el molde de fregedero durante de moldearlo. El resultado es un maravilloso tablero de cocina de una pieza del tamano de 9 pies, un extremo al otro. Tambien, moldimos las baldosas fabricados al gusto del comprador para usar en el antepecho de la ventana y "backsplash", y el proyecto es parecido con uno do nuestros otros proyectos, el tablero de una isla.

An overall shot shows the molding in place and ready for a pour. A ¾-inch sheet of melamine forms the base of the mold, beveled along the edges to create a thicker lip of concrete at the edge, and greater strength.

Este photo muestra la moldura ya esta puesto y lista para el diluvio. Un cobertor de melamina de 3/4 pulgada de grosor forma el base del molde, (beveled) en los bordes para crear un labio del concreto mas grueso al borde, y de mas fuerza.

A plywood base supports the reservoir, cut to fit the space. Excess foam from the sink reservoir was removed to make it fit snugly under the counter. The reservoir and the sink molds must be carefully aligned; both have two oversize holes for the drain knock-outs.

Un base de madera terciada soporte el deposito y esta cortado para el espacio. El exceso de espuma del deposito del fregedero estaba quitado para que puede meter bien debajo del tablero. Tiene que alinear el deposito y el molde de fregedero; los dos tiene huecos grandes para las flojaduras del sumidero.

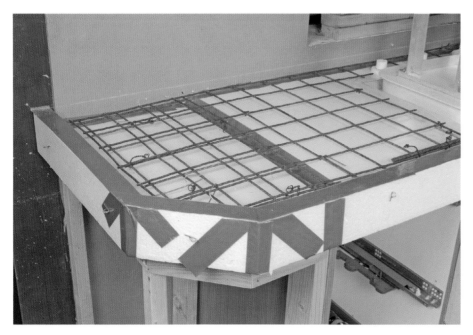

Foam forms for a bull-nose edge were treated with release and anchored to edges, the seams reinforced with vinyl tape.

Formas del espuma por un borde (bull nosed) estaba tratado con (release) y asegurado a los bores, los juntos y armado con cinta de vinilo.

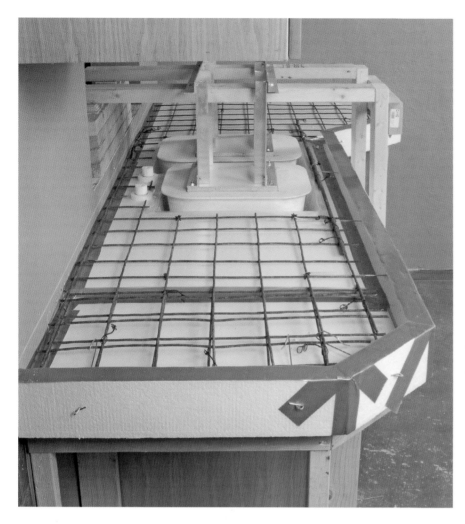

Tape, likewise, lines the interior edges of the form, protecting the cabinetry below from leakage during the pour.

Tambien, hay cinta en el interior del los bordes de la forma, protoegiendo el armario debajo de escape durante del diluvio.

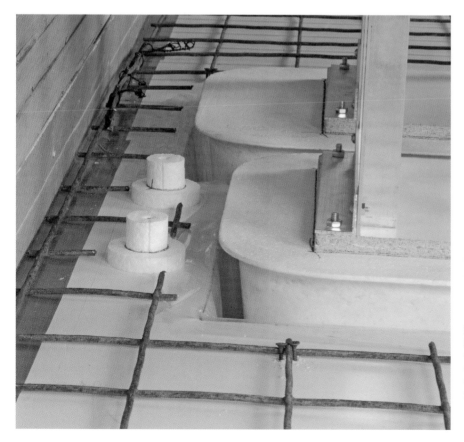

Steel reinforcement wire has been attached to the base of the mold with screws to prevent it from floating up during the pour. Likewise, knockouts have been secured to the base to create holes for a faucet and handle.

Un alambre de armazon de acero ha sido pegado al base del molde con tornillos para preventarlo de hacer flotar durante del diluvio. Tambien, han sido asegurado los (knockouts) al base para crear los huecos para los grifos y las manillas.

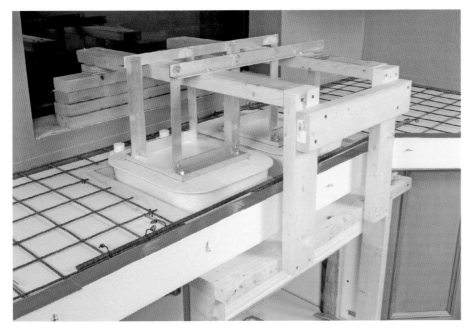

A wood and steel frame has been erected to prevent the sink molds from floating during the pour.

Un construccion de madera y acero ha sido construido para preventar los moldes del fregedero de hacer flotar durante del diluvio.

A close-up reveals the 2 x 4s supporting the base of the sink mold and the tools necessary for the pour waiting at the ready. Plywood and reservoir were pushed up to butt up underneath of the base and supported by 2 x 4s in the corner and center, cut to length to support the form.

Una foto cercano muestra los 2 x 4 que apoyan el base del molde del fregedero y las herramientas que son necesarios por el diluvio que ya estan listos. La madera terciado y el deposito estan reunidos debajo del base y apoyado por 2 x 4s en la esquina y central, cortado al largo, para apoyar la forma.

The area below the mold is carefully protected with masking tape and plastic sheeting, as is the floor.

El area debajo del molde esta protegido cuidadosamente con cinta enmarcara y cobertor plastico, igual con el suelo.

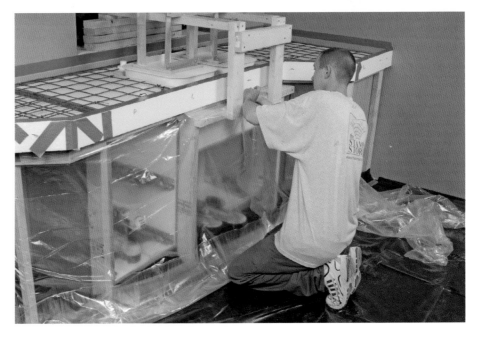

The wall is likewise protected.

Protégé la pared del misma manera.

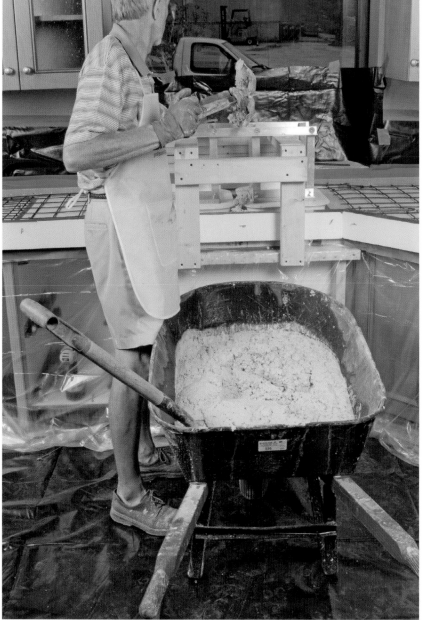

The first batch of concrete is mixed wet, and worked carefully into the openings around the double sink mold.

Mexcla el primer lote de concreto mojado y trabajo cuidadosamente en las aperturas alrededor del molde de fregedero.

A putty knife helps to encourage the concrete into the voids.

Una espatula ayuda llenar el concreto en los vacios.

A palm sander is used like a vibrator on top of the sink molds, as well as on the bottom of the reservoir, to help pack the concrete into the mold and encourage even settling.

Usa un lijador de mano come un vibrador en el parte de arriba, igual con el fondo del deposito. Este ayuda llenar duramente el concreto en el molde y tambien (encourage even settling).

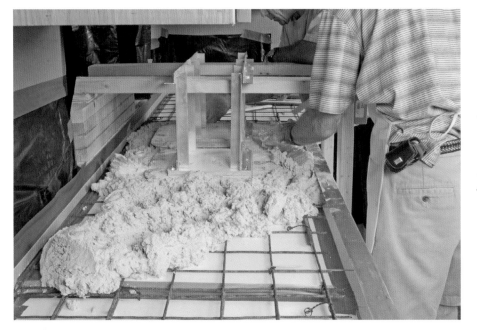

After the sink mold is packed, a dryer mix is spread through the rest of the mold.

Despues de llena firmamente el molde del fregedero, extende una mexcla mas seca al lo demas del molde.

Sturdy latex gloves allow you to get your hands into the first layer of concrete to make sure it is working its way well under the reinforcement wire.

Los guantes duros de latex permite poner las manos en las primeras capas del concreto a ver que esta llenando debajo del alambre de armazon.

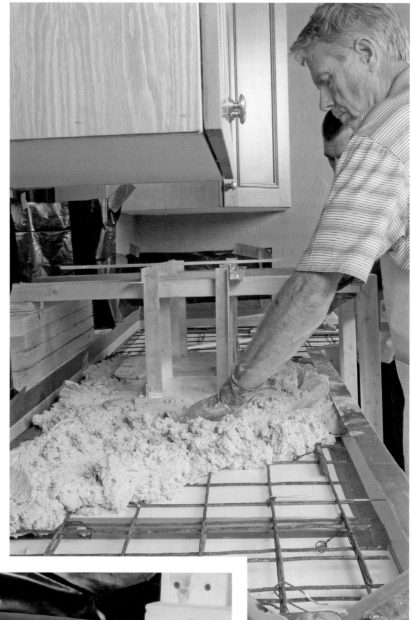

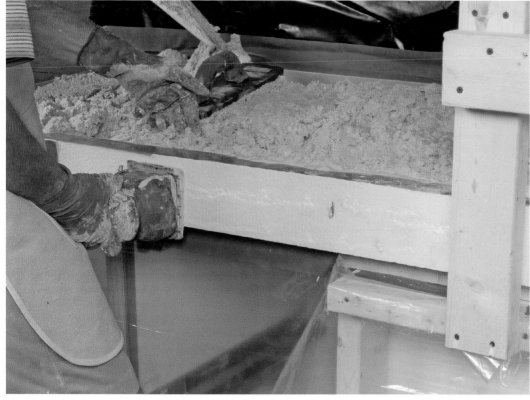

More concrete is added.

Anade mas concreto.

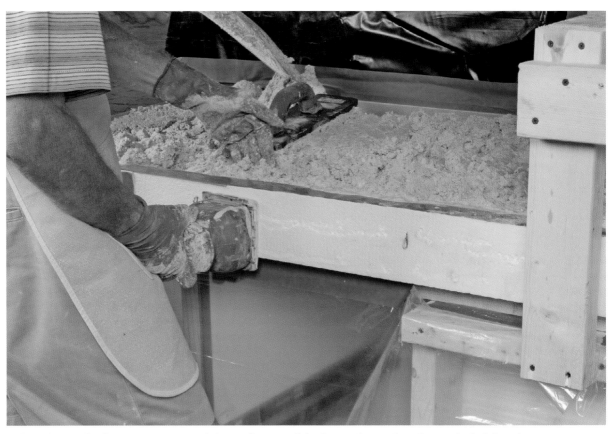

The palm sander is put to use around the perimeter of the form edge and underneath, helping the concrete to fill all the voids.

Usa el lijador de mano alrededor de el perimetro del borde de la forma y debajo. Este ayuda llenar el concreto en los vacios.

The trowel edge is put to work, pushing concrete into the bull-nosed edge.

*Extende el borde de la llana empujando el concreto al borde (*bull nosed*).*

Four-inch reinforcement rods are placed at the sink corners...

Las barras de armazon de tamano de cuatro pulgadas estan puesto a las esquinas del fregedero . . .

...and worked into place, ¼ inch below the surface. While screeding, use a level to make sure you are getting a flat surface. Water should run toward the sink, not away or toward the back.

. . . y estan trabajado en lugar, 1/4 pulgada debajo del superficie. Cuando (screeding), usa un nivel para aseguar que tiene un superficie plano. Agua debe fluir al fregedero, no atras.

When the form is filled and the surface roughly finished, the concrete is allowed to set for about an hour.

Cuando la forma esta llenado, y el superficie esta acabado asperamente, deje curar el concreto.

Meantime, we pour the ½-inch custom tiles for the backsplash. The window ledge was measured with ¼-inch clearance on the sides and back to allow for grouting and to avoid the possibility of having to grind to fit.

Al mismo tiempo echamos las baldosas especiales del tamano 1/4 pulgadas para el "backsplash" (el area contra la pared, arriba del tablero). La repisa de la ventana ha medido con un espacio en los lados y de atras para permiter extender la lechada y para evitar la posibilidad de vulcanizar para meter.

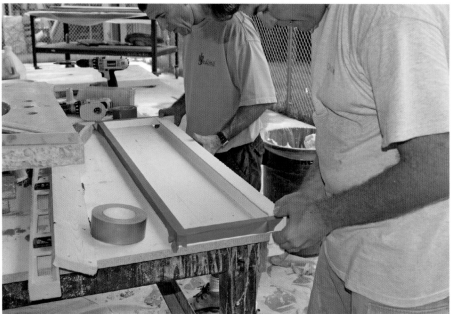

A bull-nose edge form is affixed to the end of a melamine board to create the front of the ledge.

Pega una forma de un borde de (bull nose) al fin de una tabla de melamina para crear el frente a la repisa.

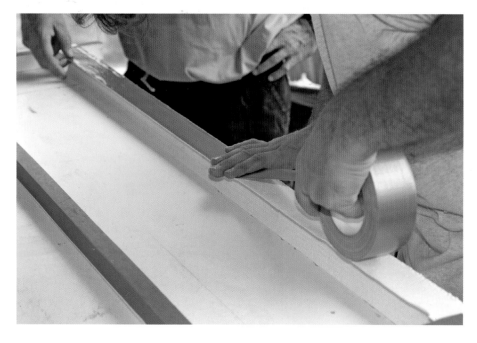

Blue masking tape ensures that the concrete will not adhere to exposed wood edges of the melamine mold walls. Vinyl tape is used across the surface of the bull-nose edge to once again to ensure that the concrete doesn't stick and that we get a smooth screeding surface.

La cinta enmarcar azul asegura que el concreto no pega al los bordes de madera descubierta de las paredes del molde de melamina. Usa cinta de vinilo sobre el superficie del borde de (bull nose) otra vez, para asegurar que el concreto no pega y tenemos un superficie alisado y (screed).

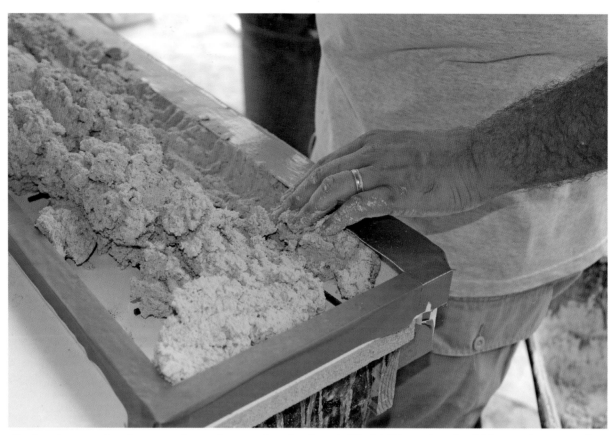

During the pour, hands are used to make sure the edge form is filled. This worker should be wearing protective gloves!

Durante del diluvio, usa las manos para asegurar que el borde de la forma esta llenado. Este trabjaero debe llevar guantes protejidos!

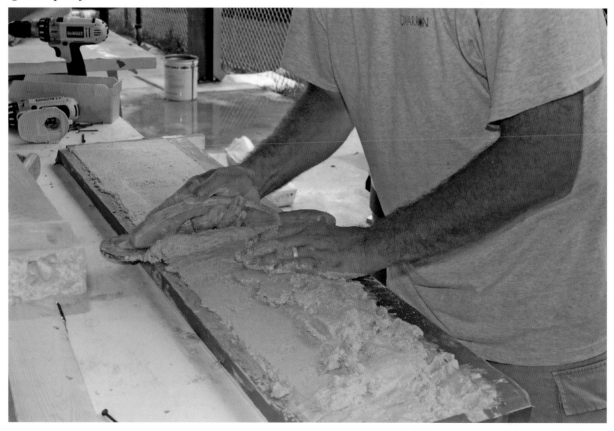

The form is screeded to create a level surface.

(Screed) la forma para crear un superficie nivel.

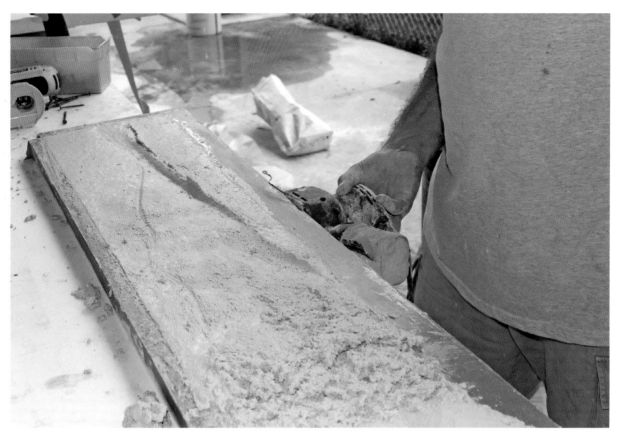

And vibrated to ensure the concrete is fully settled. The ledge will be finished like the main countertop.

Y vibrado para asegurar que el concreto ya esta (settled) Acaba la repisa como el tablero principal.

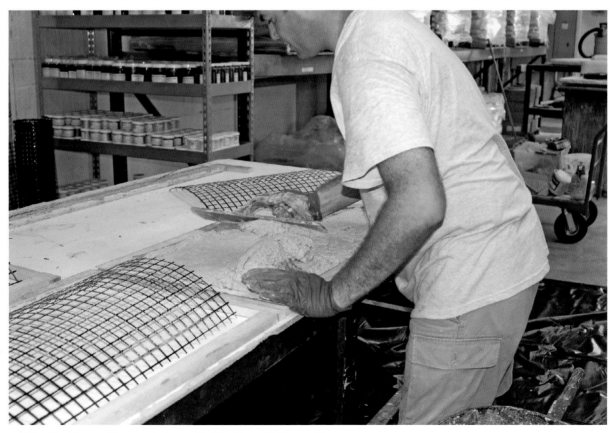

The first layer of concrete is applied to the wall tile molds.

Aplica el primer capa de concreto a las formas de las baldosas de las paredes.

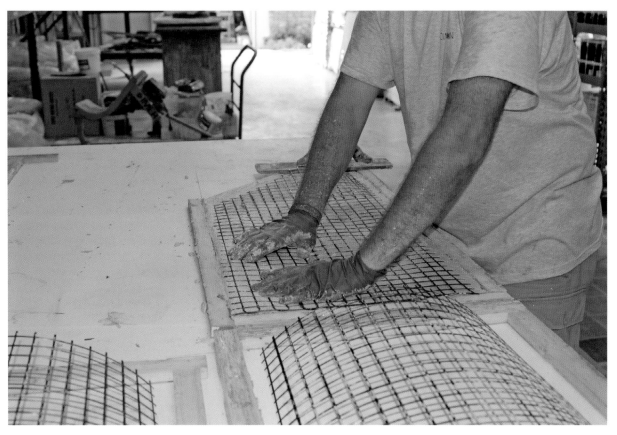

After the first layer of concrete is poured, a plastic reinforcing mesh is embedded in the layer.

Despues de echar el primer capa de concreto, una malla plastica de armazaon esta implantado en la capa.

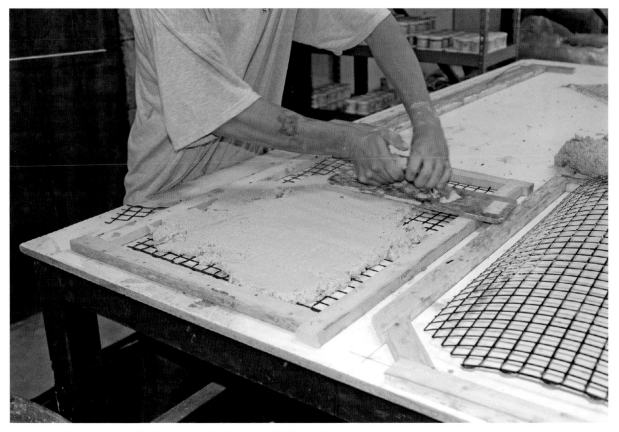

A second layer is applied over top of the embedded mesh.

Aplica un segundo cpap sobre el parte de arriba de malla implantada.

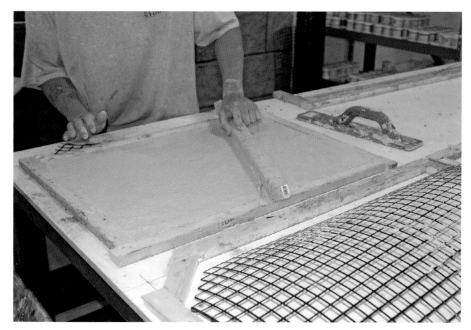

The pour is screeded to ensure it is level.

Emparejao el diluvio para asegura que es nivel.

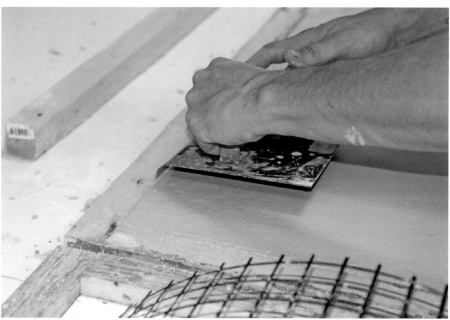

Then trowelled to get a smooth finish. Here an edge trowel is used to carefully create the edges of the tiles.

Entones, extende lla llana para un acabado alisado. Aqui usa una llana del borde para crear cuidadosamente los bordes del las baldosas.

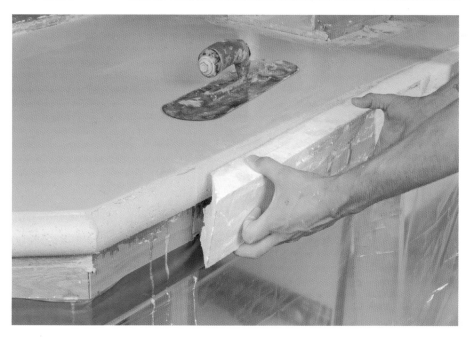

After curing for about an hour, the edge forms are removed.

Quita las formas de los bordes despues de curacion por mas o menos una hora.

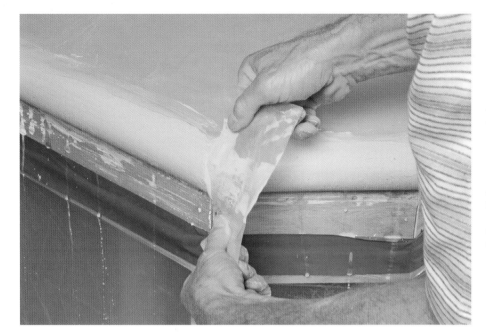

A thin slurry is applied to the surface and a piece of plastic is used to finish the bull-nose. This work should be done with care and patience to create a smooth finish.

Aplica una capa fina al superficie y un trozo de plastico esta usado para acabor (the bull nose). Hace este trabajo con cuidado y paciencia para crear un acabado alisado.

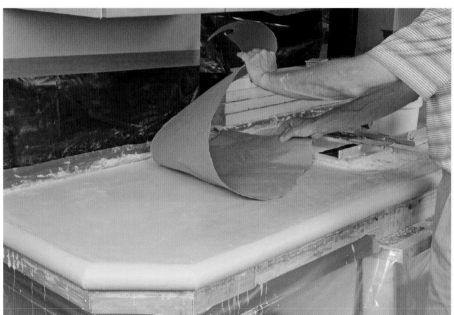

To create a two-tone effect, a sheet of heavy paper is torn and placed across the countertop.

Para crear un efecto de dos tonos, rasga un a hoja de papel duro y pone sobre el tablero.

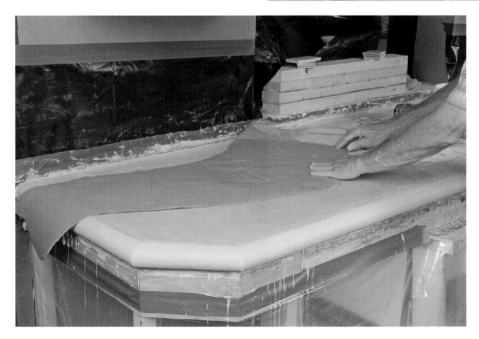

Create a look that is appealing, preferably natural and unbalanced, before proceeding.

Crea un mostra que se ve bonito, preferamente natural y desequilibrado antes de hacer mas.

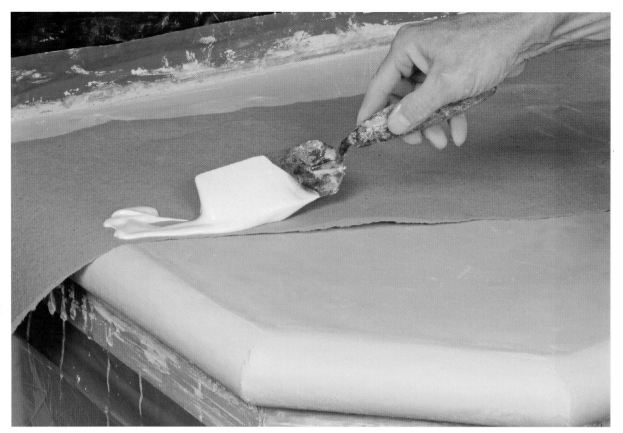

EnMAGIC is poured along the border of the paper.

Echa EnMAGIC sobre el borde del papel.

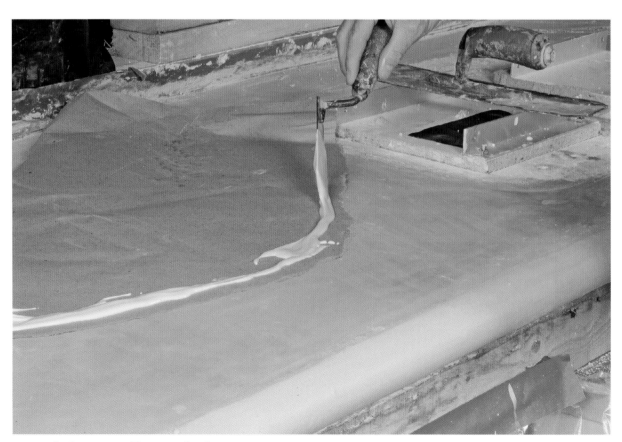

You don't want a uniform application.

No quiere una aplicacion uniforme.

The enMAGIC is then pulled with a trowel...

Extende el enMAGIC con la llana . .

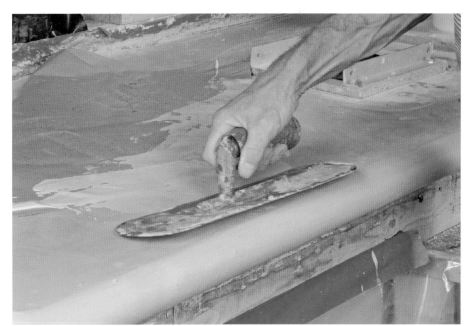

Like so.

Como asi.

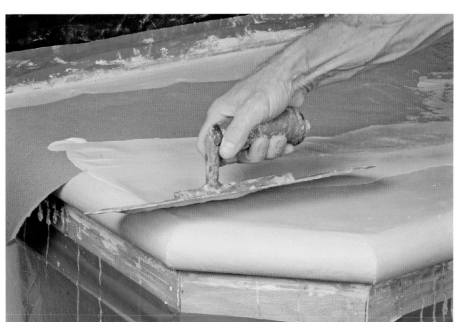

The edge can be blended with piece of wet plastic.

Puede mexclar el borde con una pieza de plastico mojado.

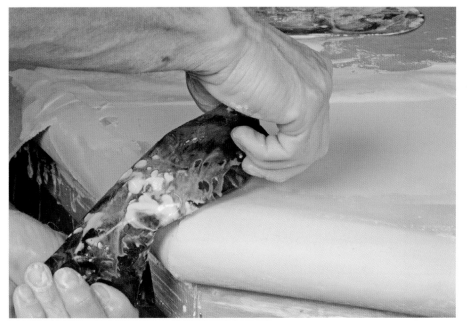

The effect is striking after the paper is removed.

Se ve especial cuando se quita el papel.

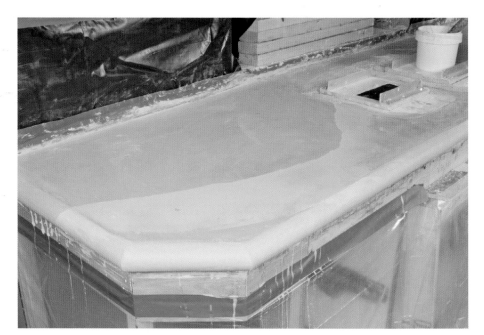

A dissimilar piece of paper is used to create the same effect on the other side of the sink.

Usa una pieza de papel diferente para crear el mismos efecto al otro lado del fregedero.

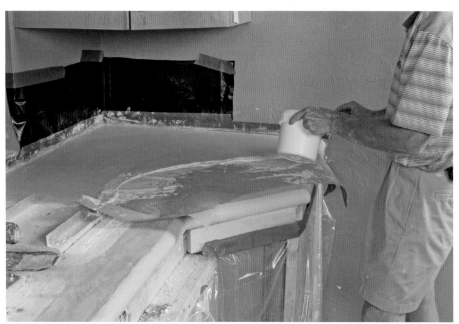

The same process is repeated, this time toward the backwall.

Hace el mismo poceso, esta vez a la pared de atras.

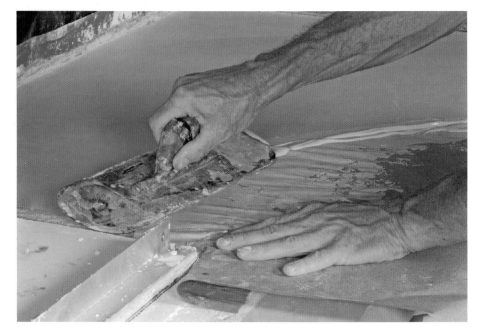

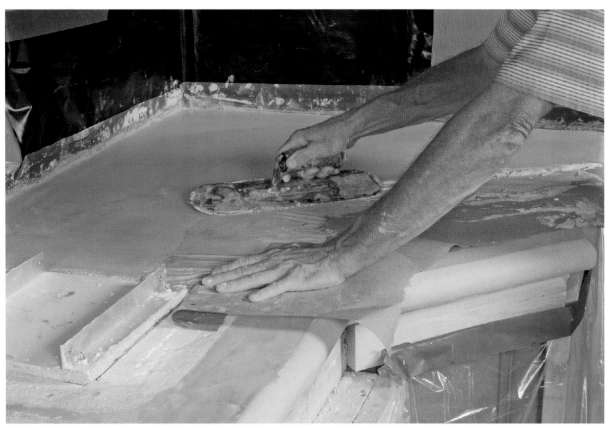

The enMAGIC is carefully smoothed.

Alisa el enMAGIC cuidadosamente.

A color-matched slurry of enMAGIC is mixed to finish the edges.

Mexcla una capa del mismo color de enMAGIC para acabar los bordes.

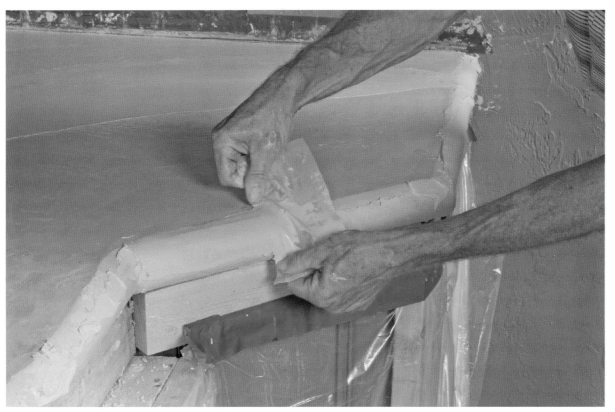

Again, simple plastic sheeting is the best tool for getting that perfect final edge.

Otra vez, un cobertor plastico sencillo es lo mejor herramienta para tener un borde perfecto y final.

The counter is covered and allowed to cure overnight. The sink molds should stay in place overnight. The plastic sheeting promotes a slower, more even cure.

Cubre el tablero y deja curar por la noche. Los moldes del fregedero puede quedar por la noche. El cobertor plastico apoya una curacion mas despacio y mas plano.

Day two, and time to remove the form.

Dia dos, y esta listo para quitar la forma.

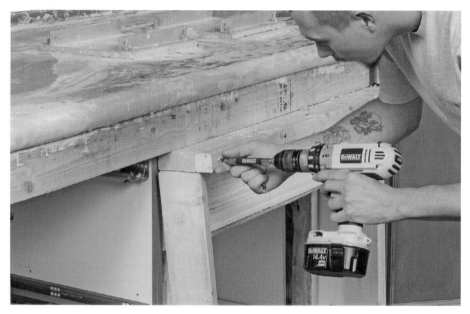

The form supporting the sink reservoir is removed.

Quita la forma que apoyar el fregedero.

Sinks often don't simply pop out. A hacksaw and general digging roots it out pretty quickly.

Normalmente, los fregederos no quitan facilmente. Usa una sierra para metales y esfuerza para quitarlo bastante rapido.

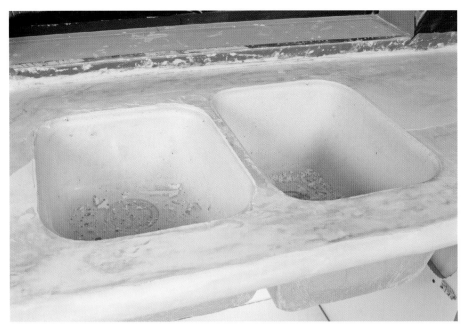

The newly revealed double sink.

El nuevo fregedero doble.

An enMAGIC slurry is applied to inside of the sinks using a rubber spatula.

Aplica una capa de enMAGIC al dentro de los fregederos , usando una espatula de goma.

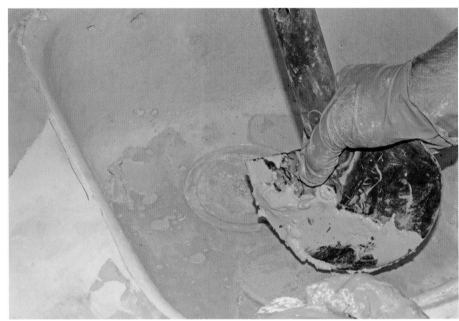

Any holes in the sink are easily patched using the enMAGIC.

Arregla algunaos huecos en el fregedero con el enMAGIC.

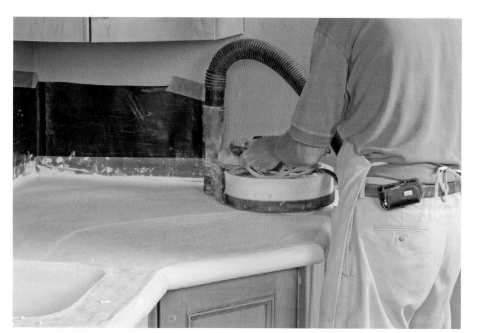

A sander is used to give a light buff to the surface.

Usa una lijadora para dar un pulido fino al superficie.

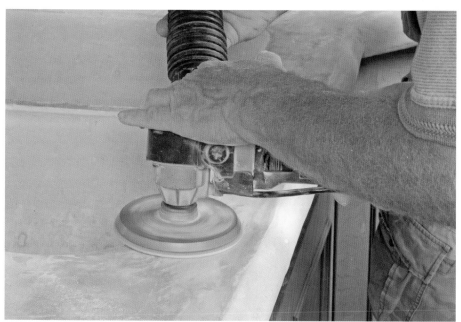

This work can be accomplished with any kind of sander, or by hand. This hard burnished surface in front of sinks was created by using a steel trowel during the pour.

Hace este trabjao con cualquier lijado-o a mano. Este superficie duro y en frente de los fregederos estaba creado por una llana de acero durante del diluvio.

A Rainbow™ water-based stain is applied to even out the tones of sink area. It is also sprayed on the backsplash tiles.

Aplica un tinte "Rainbow" del base de agua para emparejar los tones del area de fregedero. Tambien rocia en las baldosas del "backsplash" (el area detras del tablero).

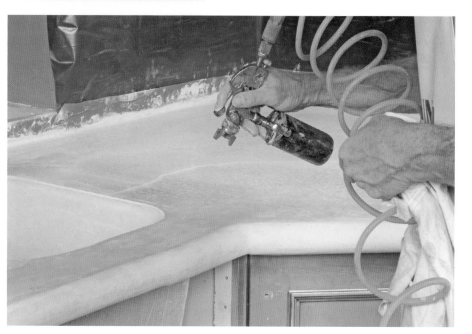

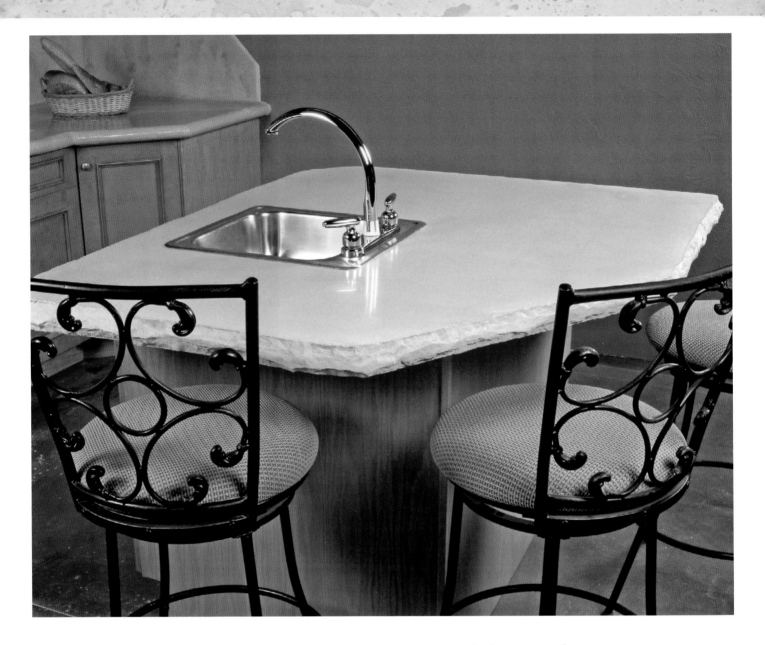

Island Countertop With Sink Knockout

Several standard floor cabinets were cobbled together to create a useful central island for our showroom kitchen. We wanted to create a great working space, complete with a small sink, as well as an overhang perfect for casual dining. The countertop was cast on a worktable, right-side up, then transported to the kitchen for installation. The countertop was poured at the same time as the cast-in-place kitchen counter, using the same formula and finishing techniques for a consistent look.

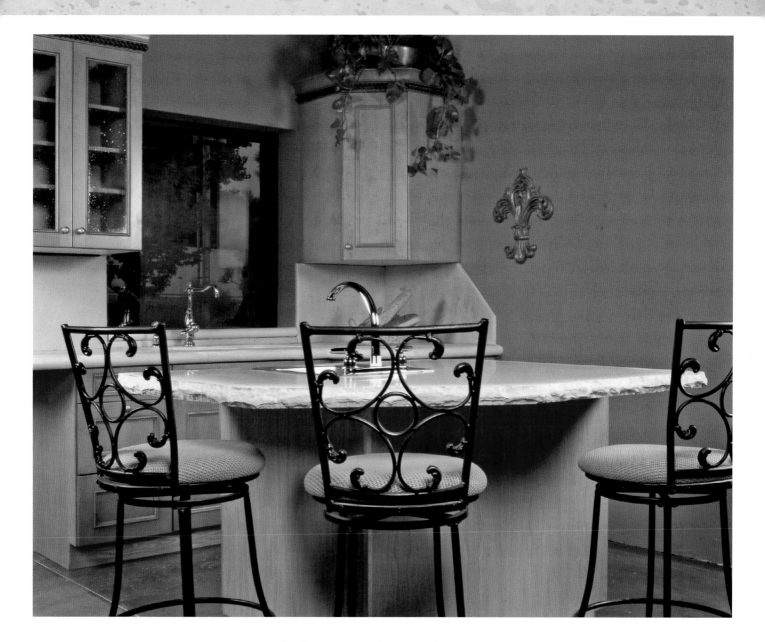

Un tablero de isla con un (Knockout) de fregedero

Unos armarios normales de suelo estaban ligado para crear una isla central para nuestra cocina de sala de exhibicion. Queriamos crear un buen espacio para trabajar con un fregedero pequeno, y tambien con un saliente perfecto por cenando casual. El tablero estaba moldeado en una mesa de trabajo, en el lado derecho, y despues trasladaba a la cocina po la instalacion. El tablero estaba echada al mismo tiempo del tablero del la la cocina moldeado en lugar, usando la misma formula y los tecnicas de acabar por un muestro consistente.

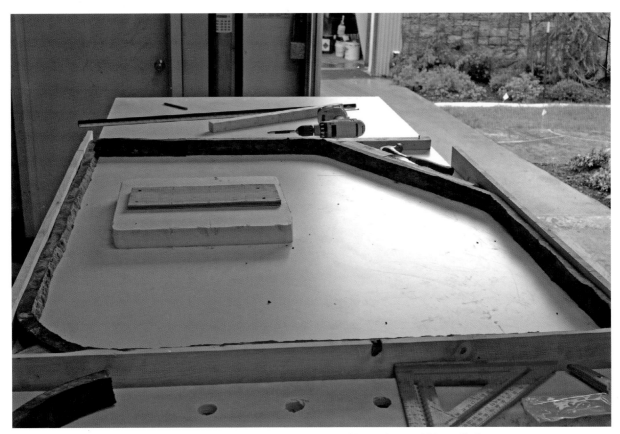

The mold is assembled, the sink knockout secured and the rubber edge mold installed.

El molde esta ensamblado, el (knockout) del fregedero esta asegurado y el borde de goma del molde esta instalado.

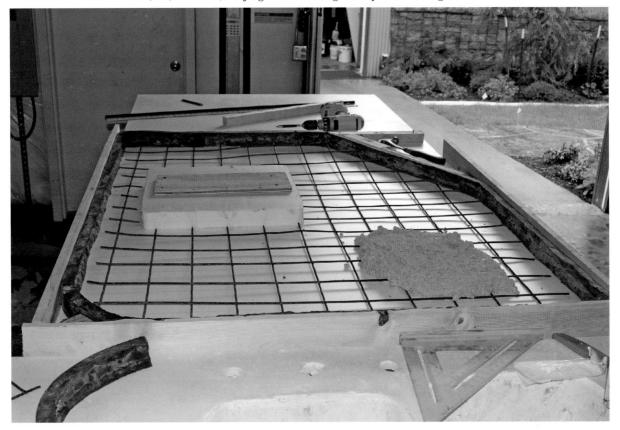

We pour right on top of the 4 x 4 x 6 reinforcement wire, then lift the wire up into the concrete to embed it.

Echamos sobre la encima del alambre de armazon de tamano 4 x 4 x 6, luego levantar el alambre al concreto para se implanta.

This is done at key points around the mold.

Hace lo mismo en puntos importantes alrededor del molde.

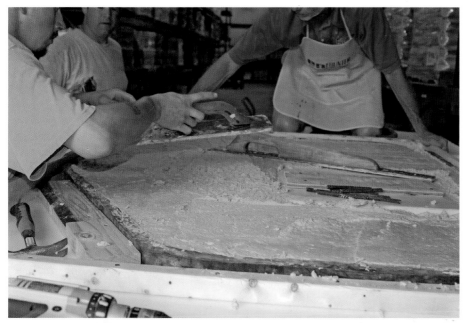

The mold is filled and screeded.

Llena y (screed) el molde.

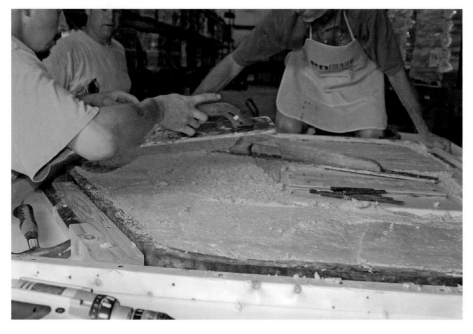

And vibrated to ensure even consolidation.

Y vibralo para asegurar que llena planamente.

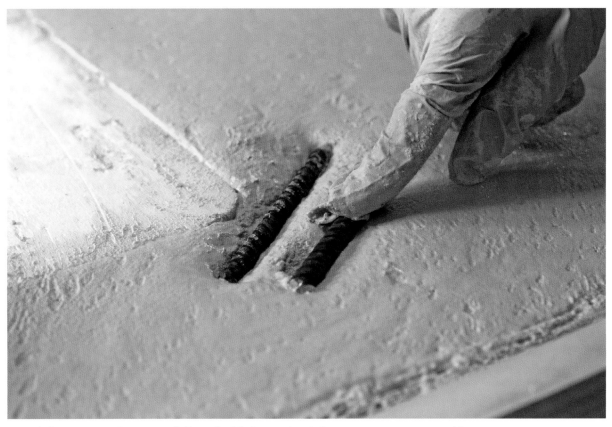

Reinforcement rods are carefully embedded near the sink corners to prevent cracking.

Las barras de armazon estan implantados cuidadosamente cerca dell las esquinas del fregedero para prohibir rajadores.

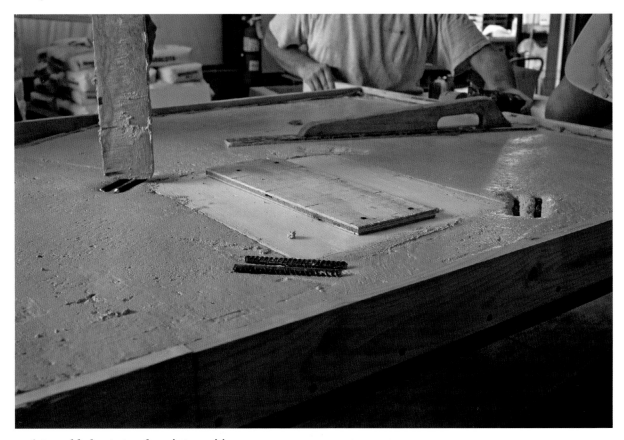

A trowel helps to tap them into position.

Una llana es util para ponerse en posicion.

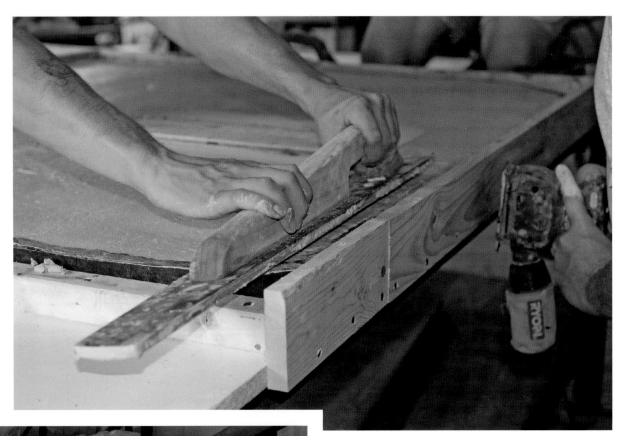

Because this countertop has such a large surface, it is important to make sure that it is level.

Porque este tablero tiene un gran superficie, es importante asegurar que es nivel.

The sink knockout provides a platform for Doug Bannister to do some multi-tasking.

El (knockout) del fregedero se pone una plataforma para que Doug Bannister hacer muchas cosas.

More reinforcement is sunk in the small expanse between sink knockout and mold.

Mas armazon esta implantado en el espacio entre el (knockout) de fregedero y el molde.

After careful finishing of the surface and edges, the mold is allowed to cure overnight.

Despues de acabar cuidadosamente el superficie y los bordes, se deja cura el molde por la noche.

The mold walls are removed after curing.

Las paredes del molde estan quitado despues de curar.

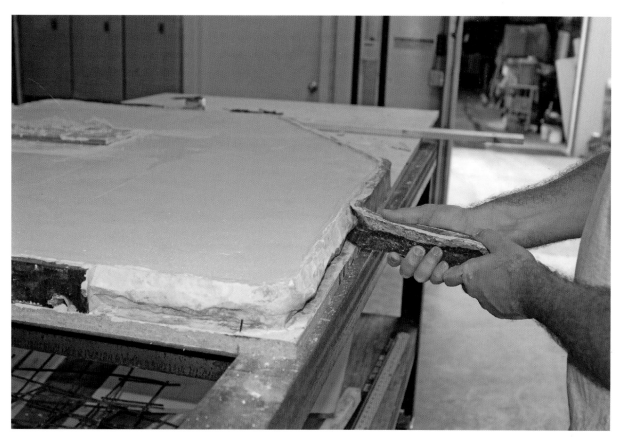

The rubber edge mold peels away easily.

Se quita el molde punto de goma facilmente.

Overlaps in areas where pieces of mold met are easily fixed...

Arregla facilmente los partes superpuestas, donde las piezas del molde se reunie . . .

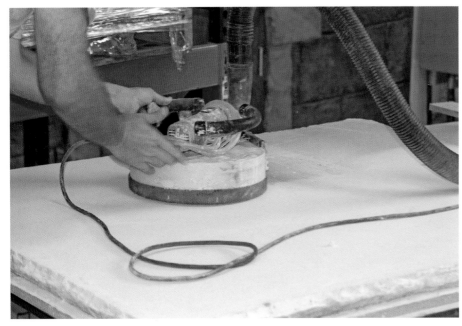

... like so.

. . . como asi.

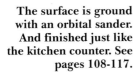

The surface is ground with an orbital sander. And finished just like the kitchen counter. See pages 108-117.

Vulcaniza el superficie con una lijador orbital. Acaba como el tablero de la cocina. Ve las paginas 108-117.

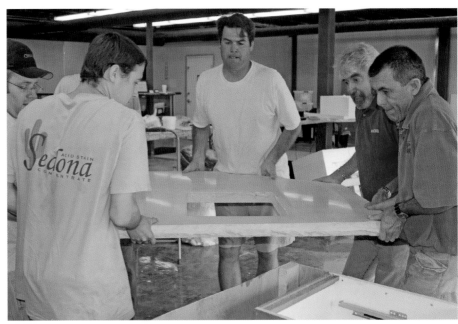

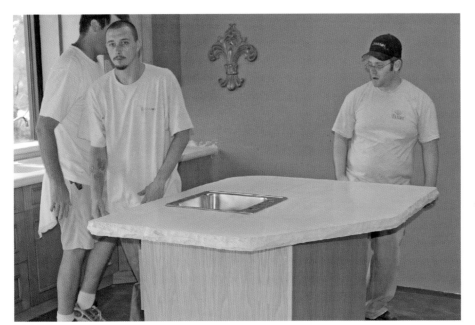

Moving the island counter is a multi-man job. The countertop is carefully placed and anchored, the drop-in sink placed.

El tablero esta puesto y asegurado , el fregedero esta puesto. Necesita mas de un hombre para trasladar el tablero de isla.

The following sink molds are now available through enCounter. Call them at 866-906-2006. View them and other products featured in this book online at encountertop.com. All of the products used in this book are available retail at The Stamp Store, 888-848-0059, thestampstore.com.

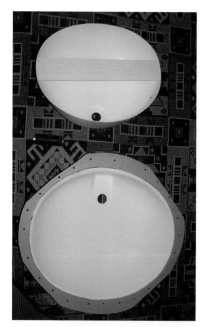

The Monolithic Vanity Sink Mold consists of the reservoir mold, the sink mold, and the drain knock-out called an enPLUG. The mold on the right is the reservoir. After cutting a hole in the countertop baseboard in the shape of the inner dimension of the reservoir, it is mounted to the underneath side of the of the countertop baseboard. On the left side of the picture is the sink mold, which provides the shape of the inside surface of your sink. A crossbar is provided to mount to a bridge you build that suspends the sink mold over the reservoir providing a ¼ inch thick sink wall. The enPLUG is made of soft rubber with a bolt through it. It is made to slide through the top sink mold, the quarter-inch gap for concrete, and the reservoir. The bolt is then tightened, which allows the rubber to expand and create a seal for the sink molds. After the concrete is poured and cured, the bolt is then loosened and the enPLUG slides out of the molds and new sink providing a clean and perfect drain hole. The sink and reservoir molds are removed leaving a monolithic countertop and sink ready for stain or the custom finish of your choice.

The Monolithic Vanity Sink Mold consiste en el molde del embalse, el molde del fregadero y la coladera del drenaje que se llama el desague (enPLUG). El molde a la derecha es el embalse. Después de cortar un agujero en la base de la tabla de la tapa de la mesa (mostrador o countertop) como en la figura de las dimensiones adentras del embalse, este es montado debajo de la base de la tabla de la tapa (mostrador o countertop) A la izquierda de la fotografía está el molde del fregadero, el cual provee la hechura de la superficie adentro de su fregadero. Una barra es proveída para montar en un puente que tiene que construir. Esta barra suspende el molde del fregadero sobre el embalse que provee un 1/4 de pulgada de gruesura (espesor) de la pared del molde. El desague (enPLUG) está hecho de hule suave con un tunillo que atraviesa de punta a punta. El tunillo es hecho para resbalarlo de la parte arriba del molde, dentro de la apretura de 1/4 de pulgada para el concreto y el embalse. El tornillo es apretado el cual hace que el tapón del hule se expande y crea un sello para los moldes de los fregaderos. Después que el concreto es vaciado y curado, entonces el tornillo es aflojado y el desague (enPLUG) es sacado de los moldes y el nuevo fregadero para proveer un agujero de drenaje perfecto y limpio. Los moldes del fregadero y del embalse son sacados, dejando una tapa de la mesa (mostrador o countertop) y un fregadero listos para pintar o decorar a su gusto.

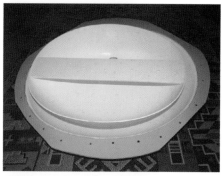

Vessel sinks are designed to sit on top of a countertop and typically have a large faucet. The Vessel Sink Mold consists of an inner mold, an outer mold, and one drain knock-out. The small foam cubes act as spacers to create a quarter-inch gap all around for a consistent wall thickness. The inner and outer molds are then clamped together and the spacers removed. The drain knock-out is then screwed to the top of the inner mold. The concrete is poured into the top of the molds. After the concrete has cured, the clamps are removed and the sink slides out of the molds. The knock-out is removed from the drain hole and a perfect vessel sink is ready for stain or the custom finish of your choice. The new production molds will be even easier to use and will eliminate the need for spacers and clamps.

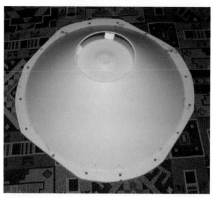

El recipiente de los fregaderos está diseñado para sentarse en la tapa de la mesa (mostrador o countertop) y típicamente tiene una llave de agua grande. El molde del recipiente del fregadero consiste en un molde interior, un molde exterior y un tapón del desague. Los pequeños cubos de esponja actúan como espacios para crear un agujero de 1/4 de pulgada en todas partes para una pared gruesa consistente. El interior y exterior de los moldes son prensados juntos uno al otro, y los espacios son sacados. Entonces, el tapón del desague es atornillado a la tapa del molde interior. Entonces, el concreto es vaciado dentro de la tapa de los moldes. Después de que el concreto es curado, las agarraderas de presión son sacadas y el fregadero es sacado de los moldes. Entonces el tapón del desague es sacado de la agujero del drenaje y un recipiente de fregadero perfecto está listo para pintar o decorar a su gusto. La nueva producción de moldes va a ser más fácil para usar y va a eliminar la necesidad para espacios y agarraderas de presión.

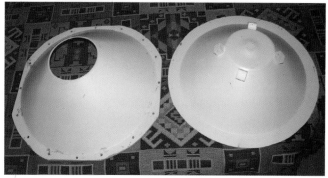

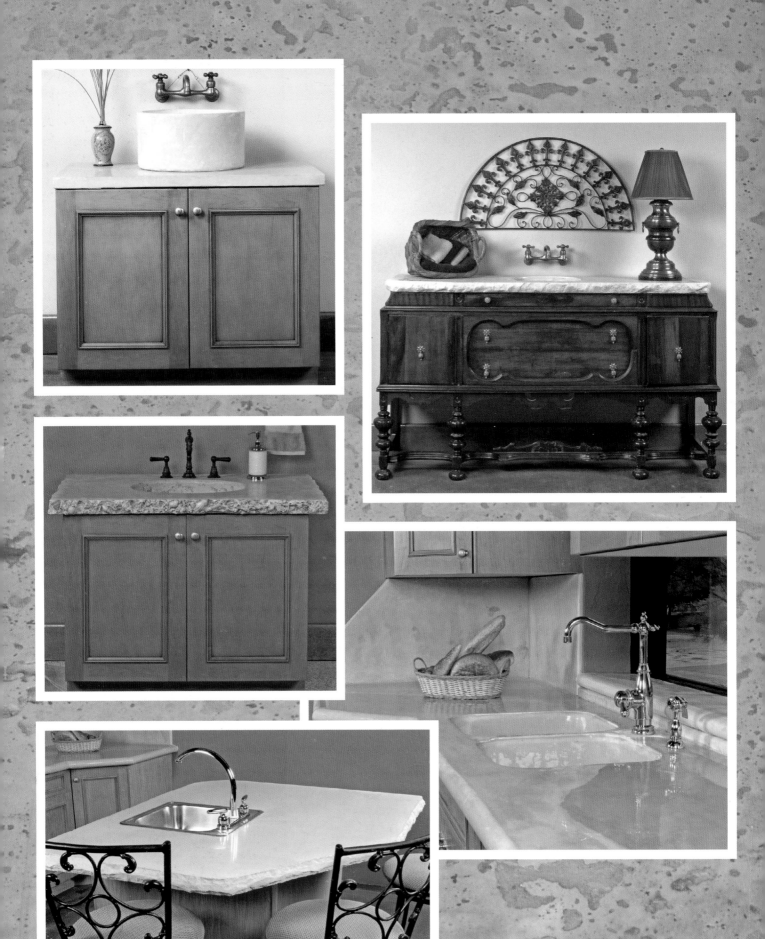